Landscape Drawing and Painting

Landscape Drawing and Painting

John O'Connor

A Studio Book
The Viking Press · New York

Copyright © John O'Connor 1977
All rights reserved
Published in 1978 by The Viking Press
625 Madison Avenue, New York, N.Y. 10022

Printed in Great Britain

Library of Congress Cataloging in Publication Data
O'Connor, John, 1913–
 Landscape drawing and painting.
 (A Studio book)
 Includes index.
 1. Landscape drawing—Technique.
 2. Landscape painting—Technique. I. Title.
NC795.037 743'.8'36 77-4849
ISBN 0-670-41772-6

Contents

Acknowledgment

The author wishes to thank all those who have helped in the preparation of this book, especially those who have loaned their work to be illustrated. Particular thanks are due to Anthony Atkinson ARCA for those on pages 49 and 50; Olwyn Bowie RA for pages 65 and 75; Peter Coker RA for pages 12, 13, 31, 34, 35, 38, 39 and 41; Ian Hay ARCA for pages 17, 22, 23, 62, 63 and 64; John Nash RA for pages 48, 88 and colour plate facing page 49; and Elizabeth Sorrell for page 65. Acknowledgment is due to the following for permission to illustrate works from their galleries:

The British Museum for those of pages 46, 47 and 86; Glasgow Art Gallery for page 86 and for the colour plate facing page 48; Münch Museum, Oslo for page 89; The National Gallery, London for pages 24, 56 and for the colour plate facing page 24; The Tate Gallery, London for pages 24 and 87; and The Victoria and Albert Museum, London for pages 25, 54, 55 and 59.

Thanks are given to the following photographers: John Adams for pages 68, 69, 70 and 71; Jane Elam for pages 52, 76, 80 and 82; Michael O'Connor for pages 45, 78 and 79; and Eric Smith for the colour plate facing page 49.

Preface

Here the term 'landscape drawing' must be read in its broadest sense to include an extensive area of work embracing the slightest of pencil notes on an inexpensive paper at one extreme, and at the other, a more complete work in a pigment medium, say watercolour, on a permanent working surface. The term 'drawing' is here intended to include the notation or statement of facts, ideas and images in any available medium whether the drawing is in colour by brush or in pencil line enclosing a large area of colour or tone.

If I encroach to a certain extent on the subject of painting, this is inevitable, as the division between painting and drawing is uncertain and indefinable. For instance, in Egyptian work of the eighteenth dynasty, figurative images were produced which could be described as 'drawn paintings', as could the vague and symbolic forms of Paul Klee and Pablo Picasso in this century, or the linear shapes of a mediaeval illuminated manuscript.

These notes are intended to help the artist who is keen to work on location and has already had some practical experience, being thus aware of the power of landscape as an originator of images, but who is still seeking additional ideas, information and advice.

The section on materials contains warnings against unsuitable, time-wasting and unsympathetic media, also advice on the choice of good materials and how to avoid their misuse.

Photographs have been used in order to 'go on location' in theory before working out of doors and it is hoped that the reader will be able to supply many additional concepts to the limited range shown in these photographs. The emphasis is on drawing and painting from land within a composite scheme of work, based on the belief that an over-accurate copy interpretation of an observed image, either in nature or from a reference, may deny the artist a number of opportunities of being flexible and original. Composite design, on the other hand, will permit accuracy in mood combined with a varied excellence in technique.

To some extent these notes are a written account of a short-term teaching project and the reader might well imagine himself or herself in conversation with a tutor, preparing materials, meeting the 'subject' in all its moods and under all conditions. The notes might thus be read as 'a word in the ear', encouraging or disturbing as the case may be, either during or after work on location.

Illustrations are from the work of artists over the past three hundred years, and where applicable, from drawings, notes and paintings by living artists made in pencil, charcoal, chalk and ink, colour or tone washes, watercolour, and gouache.

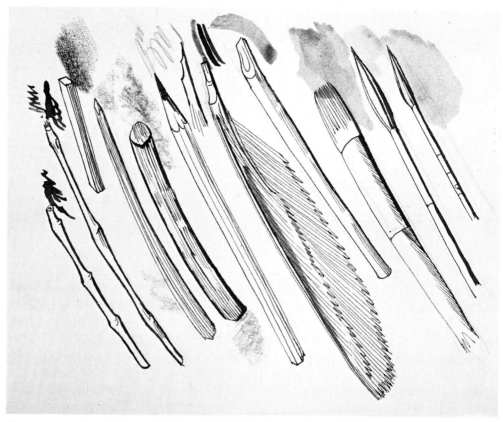

Charcoal, pencil, quill pen, reed pen (cut nib), hog's hair brush, Japanese brushes, showing characteristic markings

Materials and Techniques

There are certain points about drawing or painting out of doors, and the preparation of work for the studio, which it would be helpful to explore, and which do not usually appear in manuals and textbooks. These points are considered under the following headings:

Pigments

Coloured inks

Papers, boards and other working surfaces; trade and printing papers

Experiments with paper and media

Easels and accessories

Brushes, chalks, pencils

Working conditions; some problems.

Pigments

The following will all be found useful for drawing or painting out of doors.

Acrylic paint

Most acrylic paint is used with water, and is produced by the trade in about thirty colours and tints. Studio-size tubes should be used for primary colours – yellow, red and blue – and the largest size for white. Colours such as cobalt violet, orange vermilion, cadmium orange, cerulean blue, naples yellow, and terre vert, if required, should be purchased in small tubes. Enquiries should be made at the dealers about comparative prices of little-used colours. Some, such as orange vermilion, are expensive.

Acrylic paint is similar to gouache in many respects, and may be used in its thick, solid form or diluted. Remember that all brushes used with this paint must be washed in clean water; otherwise they will become unfit for further use, as speed and permanence of drying is one of the important properties of acrylic paints.

Gouache (opaque watercolour)

This is supplied in tubes by the trade as 'designers' colours'. These are larger than the standard watercolour tubes, but not as big as studio-sized oil tubes. It is also supplied in screw-top jars in one or two sizes. It has an opaque consistency but retains a brilliance when dry. The consistency varies with the colour, but all

Waterproof indian ink on smooth paper, drawn with a coarse quill

Non-waterproof ink on dry rough paper

Coloured ink on wet or damp rough paper

Non-waterproof ink on wet paper, allowed to dry slowly

Non-waterproof ink and chalk on damp rough paper. Note that the ink runs and spreads thinly. The chalk shows little or no difference from use on dry paper

Non-waterproof ink on Japanese medium weight paper, drawn with rough wood stick or stem of dried plant

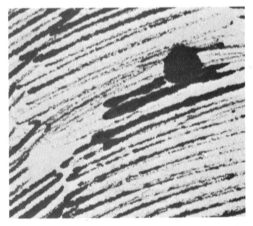

Fixed waterproof indian ink drawn with wood stick on dry paper

Non-waterproof amber coloured ink on medium thin Japanese paper drawn with a Japanese brush used vertically over loosely drawn 4B pencil marks using the side of the pencil at an angle of about 30°

Medium hard and soft pencil drawn on rough unpressed paper rubbed away with soft eraser after drawing

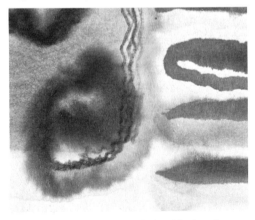

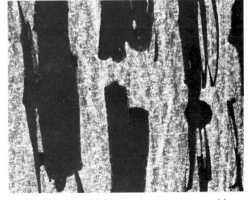

Non-waterproof ink applied with brush on Japanese paper, brush loaded with water

Waterproof indian ink drawn on cartridge paper, dry, and quickly applied over soft, non-greasy chalk in colour

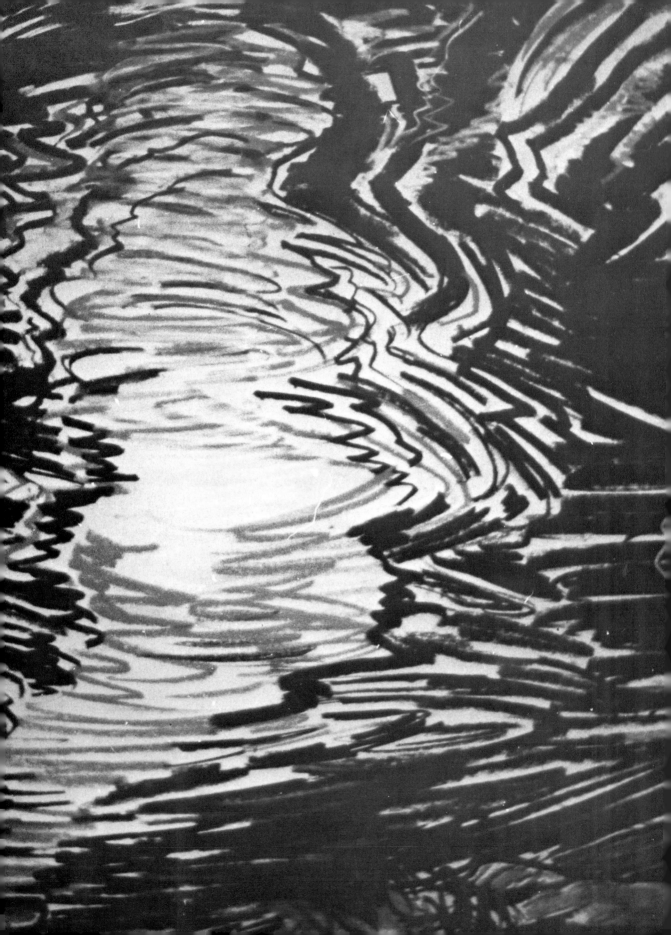

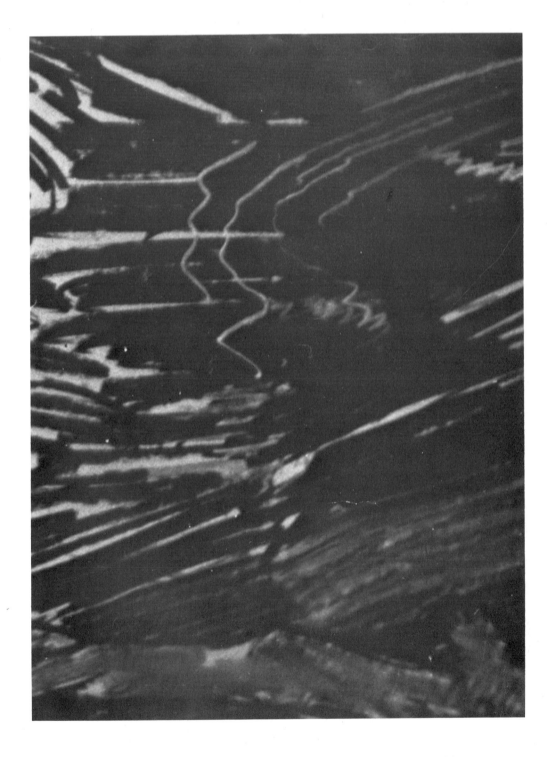

Drawn in ink-toned gouache, overdrawn with white chalk. White colour on white paper
Peter Coker

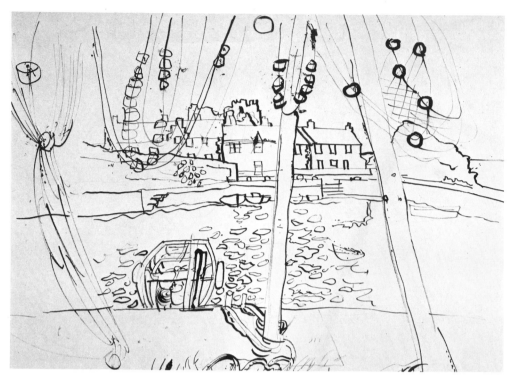

(a) Diagram drawing of a harbour on rough handmade paper using fixed chinese ink to record the whole area. This drawing was made on location in a fresh wind using dry wood sticks and reed

(b) The same area as in (a), drawn diagrammatically over a tracing frame to clarify the items, from the original ink drawing made on location in non-waterproof chinese or indian ink with a standard dip pen nib

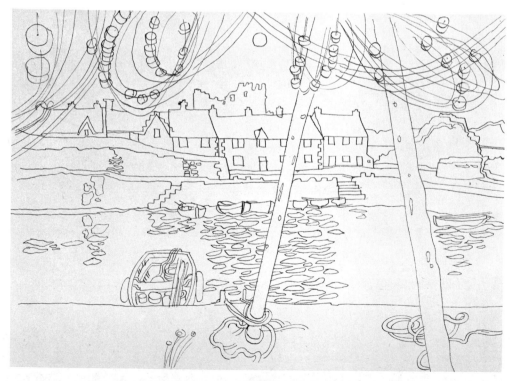

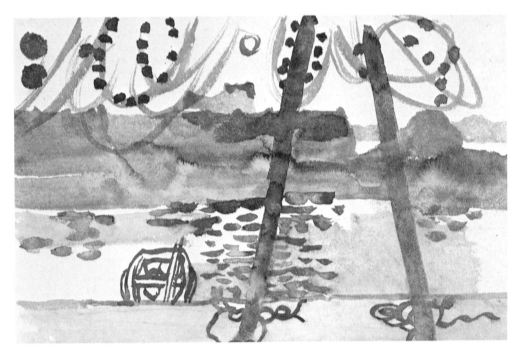

(c) The harbour area drawn diagrammatically over tracing frame from (a) on a semi-smooth handmade paper in chinese ink, soluble in water, using a watercolour brush. It may be noted that in this drawing the whole complex, ie buildings, castle area and nets, has been included in the scheme. This drawing illustrates also the selection of image referred to in a later section

(d) Drawing over a tracing frame from (a) using chinese ink, not soluble in water. This drawing when compared with (a), (b) and (c) also illustrates the process of selection of image, referred to later. Here the whole foreground materials of poles and fishing gear have been optically removed, leaving simply the land, castle and cottages with reflection in the harbour water

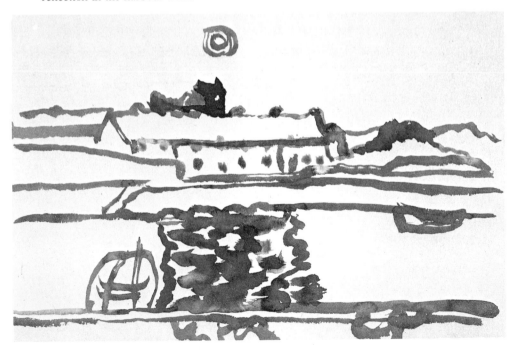

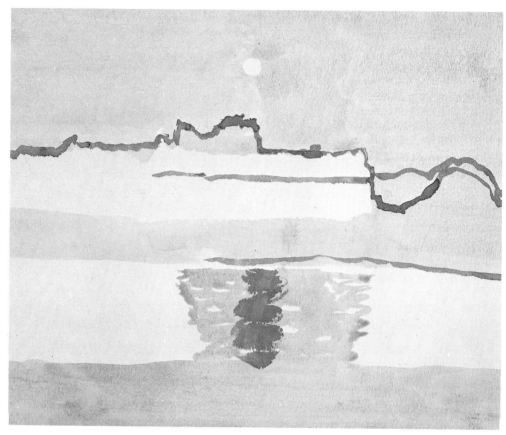

(e) This tracing frame drawing has been made on handmade paper using a wash of diluted toned ink and drawn brush lines for information about the castle, rock and reflection. Again to anticipate the notes on 'selection of image' it will be noticed that the boat with floats has been removed as well as all other items reported in the original black ink drawing (a). Compare the misty sun in the drawing with the more brilliantly suggested sun in (d) and in the original (a)

colours are pasty like very soft putty. It is important to wash brushes regularly when using gouache in conjunction with watercolour (as one might do out of doors) since the body in gouache will impair the clarity of any watercolour in use at the same time. Otherwise, gouache and watercolour may be mixed safely and satisfactorily, but it is important to remember that once gouache paint has made a surface, a pale watercolour will be reduced in power if used over it.

Watercolour

This has been considered essentially an English and American medium, especially since the eighteenth century. It is, in fact, suitable for the wet climate of Great Britain and the humid North-eastern United States, although it is adaptable to most climates. In very warm temperatures it can be used so long as liquid is available, and it is also possible to manage in several degrees of frost, even if ice settles on the brush and the palette.

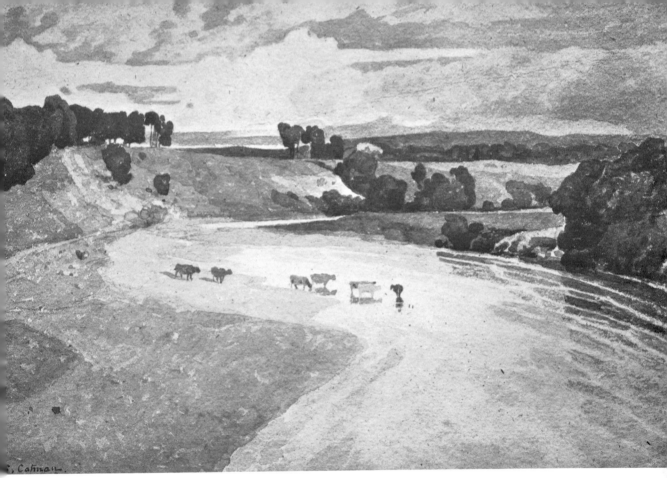

Detail from *Landscape with river and cattle* by J. S. Cotman
Watercolour on handmade paper

The pigment may be used easily in the form of dry cakes or sticks, but on location it is a hindrance to rub from dry colour blocks. In many ways tubes are best. Pigment may be spread on to the dry paper and worked with a water-loaded brush, or the palest or most delicate tint of colour may be applied from a smear on the palette mixed with plenty of water. Do not expect miracles of watercolour as it is a medium which soon exposes the limitations of the artist.

Prices of watercolours vary a little between tints. The choice of colour is almost the same as for oil paint, although generally a wider range is available; for example, among the many colours supplied by the trade (and often neglected) are Hooker's light and dark green, and the delicate tint, Davies grey.

It is a good idea to carry about twelve colours. A possible choice might be: in *yellows*, cadmium, lemon, yellow ochre (not gamboge, which is demanding and will probably spoil other colour schemes); in *blues*, ultramarine, french blue, cerulean, and, in very small quantities, prussian blue; in *reds*, madder or alizarin, cadmium red, cadmium orange, indian red; and in additional colours, pale browns, greens, purple and white (gouache white is well suited to mixing with watercolours.

17

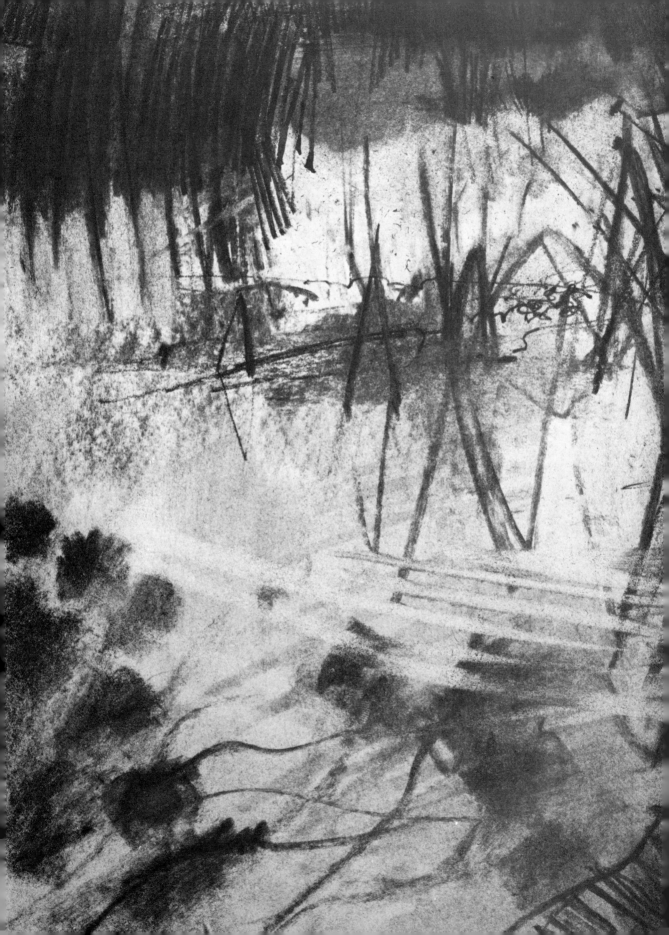

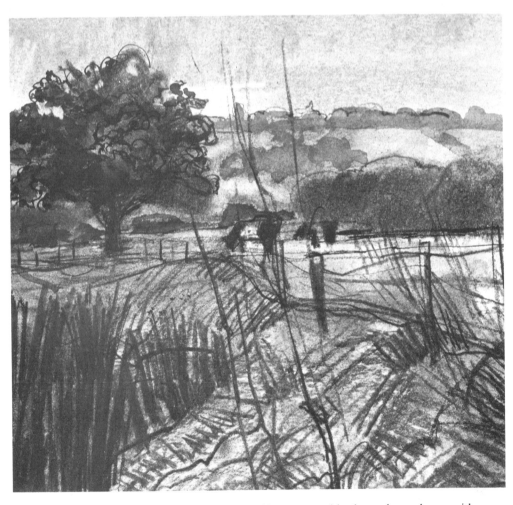

Three details of a drawing made on cartridge paper with charcoal overdrawn with
ink-conté pencil, lightly softened ink, thinned with water. Lightest areas redrawn by
removal of charcoal and chalk with eraser and rag Ian Hay

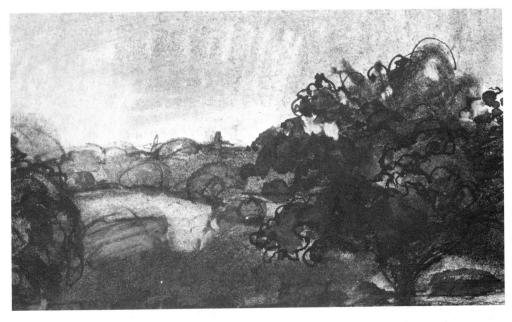

Pencil drawing with 2B or 3B pencil on smooth watercolour paper. Some additional
lines in coloured pencil

Drawing in 6B pencil on mature Whatman hot pressed paper smudged with water.
Some drawing has been added with a harder pencil, probably an HB grade

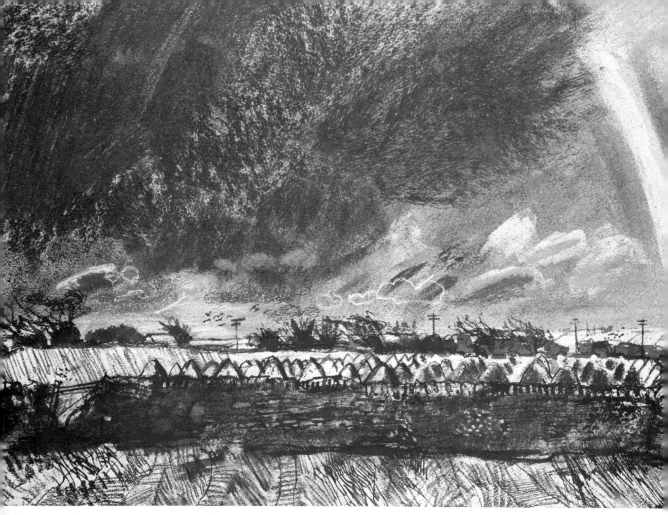

Drawing on good quality watercolour paper in conté crayon. Some white gouache paint, indian ink, washed in thinned indian ink in some areas. Details are added with several areas of chalk and crayon in sky rubbed over in two or three layers

Of all media, watercolour is the easiest to transport, although a little time should be allowed if possible before packing after work. They should be protected from heat and kept as moist as possible, with a damp rag.

Coloured inks

These are generally prepared in two varieties; waterproof and non-waterproof. They should never be mixed except in experienced hands, since waterproof ink dries quickly and permanently, and is, of course, not again soluble.

Unless working in flat areas of colour, which are impersonal in character, an artist may prefer non-waterproof inks because they can be diluted easily and may be used on almost any surface that is not too glossy or oily. Their permanency is

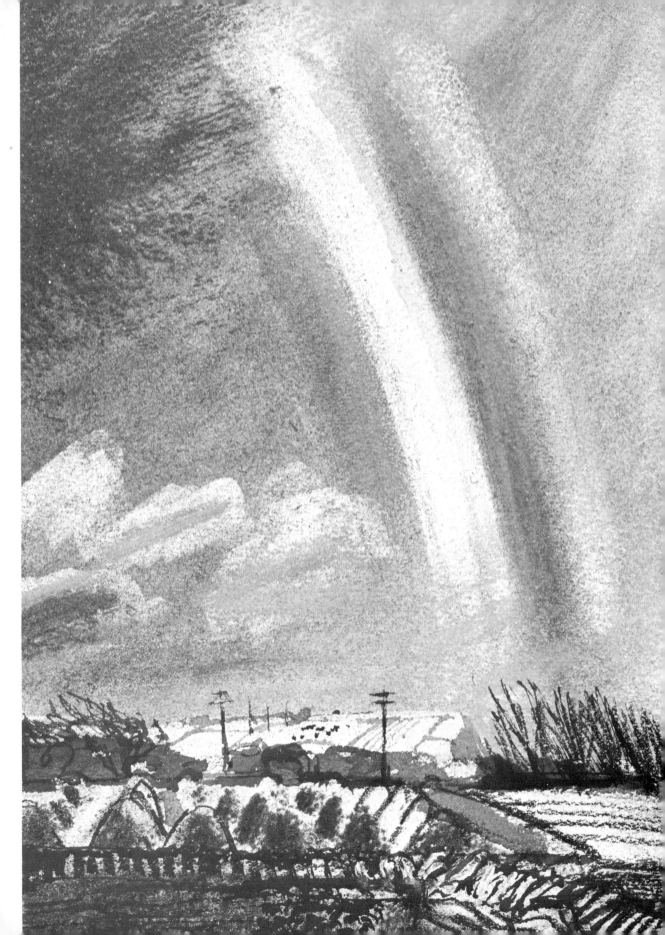

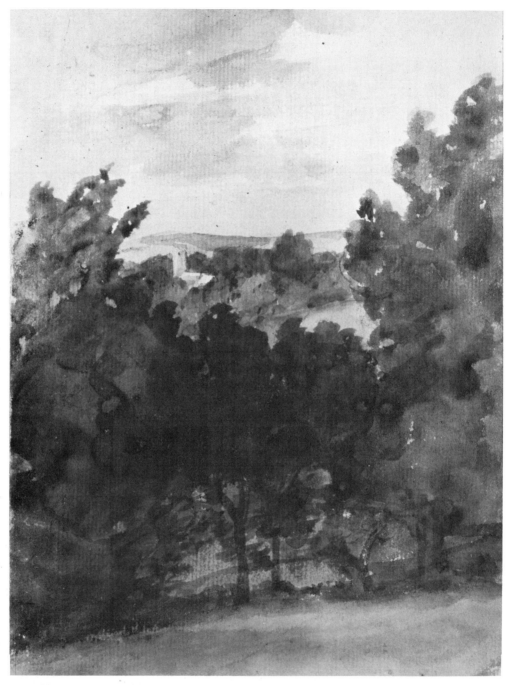

Sketch by John Constable with complete tonal information, drawn with brush on handmade paper. In this sketch the tree profile on the left is as completely stated as the shapes would be in a completed painting. The Tate Gallery, London

(Opposite) Detail from *The Cornfield* by John Constable
The National Gallery, London

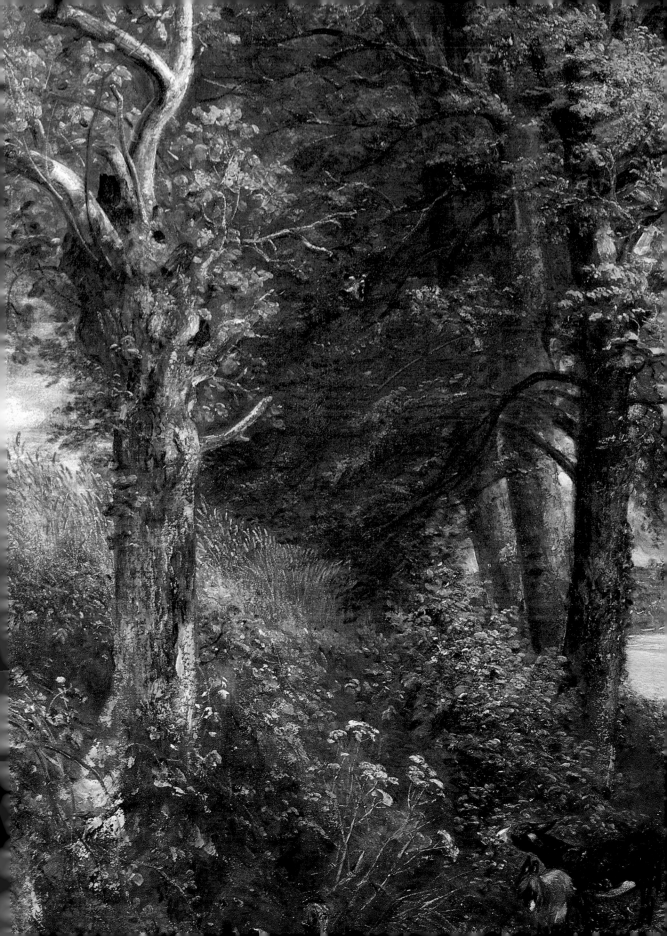

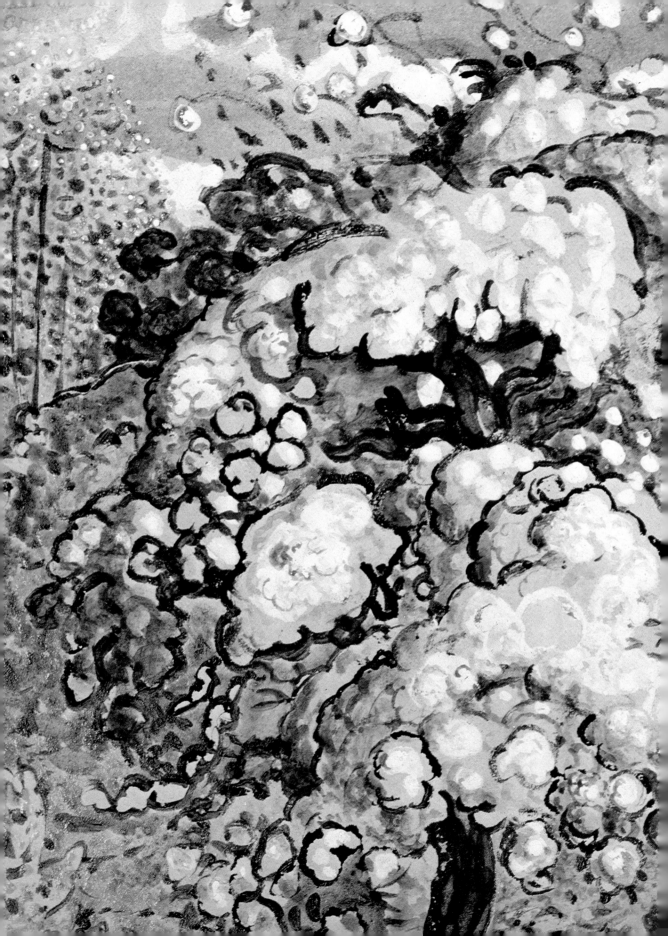

variable, and trade catalogues should be consulted on this point – as of course they should when buying any type of paint.

Chinese ink, obtainable in stick form, is prepared in bottles by Winsor and Newton, and will mix well with any other water-bound material. When using these inks, however, great care must be taken to wash brushes thoroughly, as a favourite brush used for some heavier ink will become rather gritty and unusable for watercolour.

Papers, boards and other working surfaces
The use of trade and printing papers

Information about paper is difficult and sometimes impossible to obtain from handbooks dealing with painting techniques or from dealers' lists and catalogues. However, there is a great choice of papers to be had, and the selection of a suitable one is most important. Every artist needs to experiment to find those that suit him best. It is not uncommon for an inexperienced artist to set off happily on a painting holiday, only to find himself in a remote area with a stock of paper entirely unsuited for use in that environment.

It is a good idea to experiment widely with rough papers with irregular surfaces which greedily absorb water or oil, and which will not crack with reasonable handling; also experiment with those tempting lightweight papers which offer rapid absorption but will not stand the strain of drawing with a pencil or the more violent use of brushes. It is true that sometimes an unsatisfactory paper and medium will encourage an artist to produce a more virile drawing through the need to record the occasion. The sun behind a mountain will be no less remembered for being noted in sticky mud or scratched with a bent nail on a piece of cardboard.

A good reliable paper is not an easy thing to acquire. Some stocks of old paper exist, and dealers will offer a variety of watercolour papers. Compared with canvas, paper is not expensive, allowing for the fact that no stretcher is required. Buying the best paper should not be regarded as an extravagance; it must be reasonably expensive to be any good at all, and a paper upon which several hours of work may be made is worth a modest investment.

Papers can only be proved by trial and error. One can choose between soft and hard papers, ie those with a soft size content which will absorb moisture quickly (the extreme is blotting paper) and those which are hard sized and pressed in machine rollers to give a hard smooth surface which will absorb moisture slowly (super-calendered [shiny] papers are the extreme in this range).

Other papers suitable for sketching are:
Ingres Manufactured in white or pale tones (these are likely to modify paint colours slightly) with a reasonably quick absorption. It can be stretched easily by

(Opposite) Detail from *In a Shoreham Garden* by Samuel Palmer
Victoria and Albert Museum, London

25

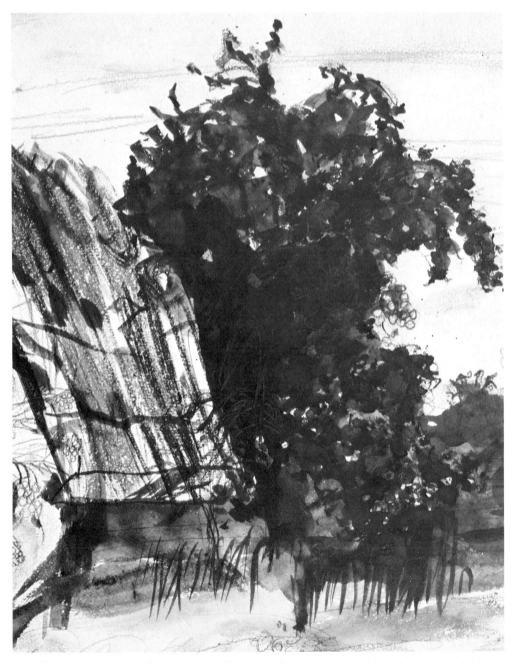

Drawing on handmade paper using a basic pencil and water colour in dark green; added drawing in chinese waterproof stick ink, using a thin reed or stick, and finally colour of fruit, etc, added by use of yellow and red gouache colour

◄ Drawing on lightweight cartridge paper made with medium pencils, smudged into tone by crushed grasses or green leaves from location

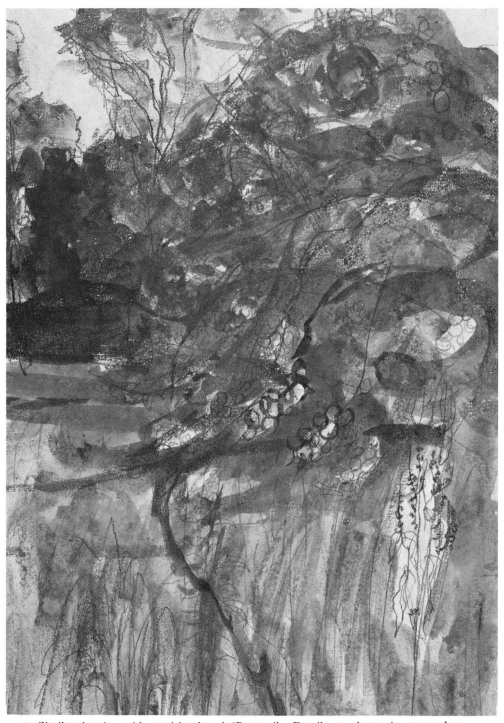

Similar drawing with semi-hard and 6B pencils. Details are drawn in watercolour, gouache and colour slightly darkened by adding thin chinese ink

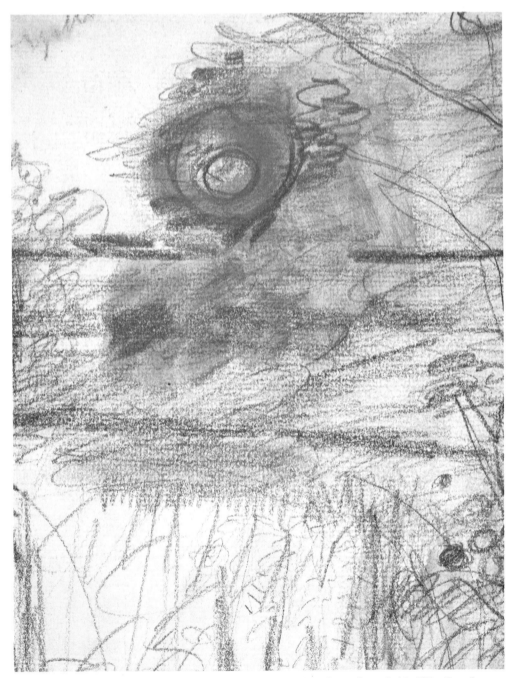

Sketch drawn on handmade paper using several grades of pencil, probably HB, 2B and 4 or 6B for the emphasis in the horizontal hedge lines and smudge round the sun. Here the use of a dark area to suggest or remind the artist of a golden or bright red sun without use of actual colour pigment. Black is here allowed to assume the vibration and quality of scarlet or bright orange

damping on a board with gummed or taped-down edges: the American Strathmore is similar.

Michallet A little tougher than Ingres, otherwise similar. It shows machine lines on the surface from drying racks during manufacture.

Cartridge or white drawing paper Produced in many qualities. It is white and strong, but cheaper grades will fade and yellow in a short time, especially if exposed to light. Good quality cartridge (drawing) paper is as suitable as any for general purposes. A number of surfaces are obtainable from smooth to a slightly rough, dry and absorbent surface. If possible, do not roll it, but carry it flat.

Japanese papers Made in a very wide range. Those most commonly used are the medium light weight which are too strong to tear and the heavier sized papers which are not so absorbent. The latter will resist water to some extent, but offer a benign and sometimes toned surface. Thin tissues are not recommended for drawing as they tear easily and are too absorbent.

Japanese paper should not require stretching and is generally ready for immediate use. The heavier weights will crack if not handled carefully, and the soft surface papers will pick up the slightest blemish of chalk or thumbprint which are very difficult to remove.

Handmade This is a top class paper group in 'fine art' work, but the name does not necessarily imply the individual workmanship of the past. A good quality handmade paper will be strong, fast to light, and available in a number of surfaces, such as:

Hot-pressed paper This is a basically rough paper, but has passed through a rolling machine to produce a much smoother, harder surface. It is less rapid in absorption of moisture or medium than untreated paper and is velvety or marble-like to the touch. It has a sensuous surface with some of the qualities of polished wood.

A 'not' (rough or cold-pressed) paper A rough-surfaced paper which has not been pressed, and has been allowed to set in a variety of grades of surface. This may be very rough indeed or medium-rough like a piece of dry plaster, and will be reasonably absorbent.

There are several other brands of handmade papers, and information about these can usually be obtained from dealers in artists' materials, who will say whether or not they are in short supply.

Good papers can be obtained from a number of places. It is a good idea to have a word with a master printer or the department manager of a printing house who may know of a number of papers available to the printing industry which are also very suitable for drawing and painting. Some printing papers used by the trade are especially attractive, and a few notes about them may be helpful. Look for *'wove' papers* which are medium soft-size. These are excellent for some artists' type of work, for drawing and painting in pencil, chalks, watercolour, or gouache. Compared with handmade papers they are not expensive.

A 'laid' paper of which there are many varieties, is good, whether it is an 'antique'

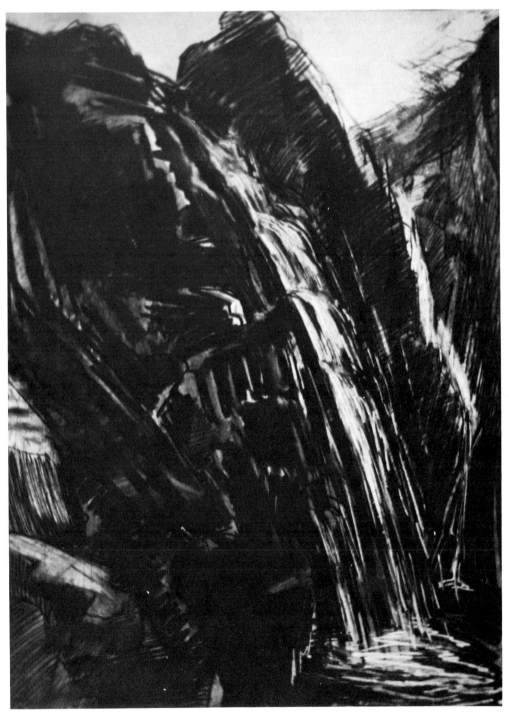

Drawing in charcoal, black ink, dark chalk with additional light lines by use of a white
gouache
 Peter Coker

or bears any other trade label. They are similar from the artist's point of view. There will generally be lines from the rack of the paper machine on the surface, and the watermark may be quite prominent.

'Parchments' in a trade list are sometimes a little smooth for drawing, but there are some excellent papers in this range. A warning – they can be brittle, and although good for book production, will not remain undamaged in the much larger single sheet size. (A book is rarely larger than a sheet of typing paper.)

Printing trade lithographic or *offset paper* can be very good for drawing, but should of course be tested and used by the artist before he accepts a large amount of it.

For producing a large version of a picture, an artist would be well advised to use *brown (wrapping) paper*, which is good to draw on and which can be obtained in much larger sizes than white paper.

It is as well to avoid all papers with specially prepared surfaces, such as imitation vellums or leather textured papers as, with this excessive texture, they tend to leave watercolour lying about on the surface. Glossy papers are also difficult to use without experience, unless of course one is aiming at the break-up of colour which will result from their use.

Generally, a rough-surfaced paper containing only a little size will absorb an artist's medium extremely quickly. The degree of sizing is important because a rough paper may look tempting on the counter of an art supply shop, but may prove unpleasant to use, if, as is sometimes the case with a rough paper, it is hard and non-absorbent. This means slow drying, which may be desirable in some instances, but a running together of colours which were intended to remain independent can be a disadvantage. It is best to be able to handle and even to moisten a specimen before choosing, and some dealers will supply a testing sheet for customers. If the size is light, the paper should bend in a gentle curve, and be supple when handled. The presence of a hardening or synthetic material, perfectly suitable for display or printing industry use, would make the paper brittle and unsympathetic.

Once a paper or group of papers has been chosen, it is a good idea to use one or two favourites for a while in order to find out to what extent paper technology helps the artist in the mastery of desired techniques.

It is wise to collect as many types of paper as possible at any time, but do not keep them rolled or in a tube. Tubed paper gains tension in the roll, and can become one of the most irritating factors in the whole business of drawing and painting. One method of dealing with tubed paper is to re-roll it gently round a tube in the opposite direction and leave it for several hours before using. The tube should be at least 50–76 mm (2 to 3 in.) in diameter and inflexible.

This method should not be used for a thick-coated or 'crackable' paper. To flatten such a paper there is a method which is suitable for any paper in stock. Lay the sheets face downwards (the watermark is readable on the right side) on a flat, clean, hard surface which is larger than the paper, so that the edges do not get

damaged. Put a second piece of cardboard, or hardboard, of the same size, over this and press with something heavy (books for example). Most papers will be ready for use in a day or two after this treatment, and should not need drawing pins, thumb tacks, or clips.

It is most important that the paper storage place should be quite dry; paper can be kept in dry conditions for many years without coming to any harm.

Card and board These are usually bought by the trade in bulk, and it is as well to try to persuade a printer to let one buy a small quantity, a quire (about twenty sheets) or two, or half a ream (300–500 sheets depending on weight) at a time.

Card (fashion board) and board sometimes present difficulties because only good white or permanently toned cardboard should be used. Cheap card (or fashion board) will probably go yellow quickly and crack; also, mildew can form and a glue or paste may appear in texture through the surface.

A card cannot cockle or wrinkle on its surface. This is an advantage, but a good paper need not do so either if it is held down firmly and is not 'springing' before one starts work. 'Illustration' board, 'fashion' board and 'paste' board are trade names for these stronger surfaces, and it is best to buy a reasonably expensive one.

Boards are made in rough, medium or smooth surfaces. An overlay of protective paper may be used to keep the working surface clear in case of friction during movement. This is more likely to occur on board than on paper. Boards are, of course, heavy by comparison.

Experiments with paper and media

Here are some notes on testing the properties of papers in a series of interesting experiments.

Tear a sheet of paper into several pieces. This will show if there is a tendency to crack and wrinkle, or if the paper is likely to tear in use. A good, sturdy paper will tear along the fold made by hand pressure. A cheap, poor quality paper will probably tear in unexpected places, or a piece may literally come away in the hand. The good paper will tear into usable pieces, ie the torn sections will not be damaged. Note that Japanese papers, thin or thick, may not be tested in this way; they are in a category of their own, and form a strong direction of grain in the production process.

Dip pieces of paper into dye, ink or paint, and test their drying qualities. Splash any medium – oil, water, turpentine – over the surface, and again test drying time to see if the colour of the pigment changes much during the drying process. If there is a change it will generally be disappointing, for example, a drawing or painting made in a rich blue and velvety black may dry into a muddy blue-grey and a pale brown. If the pigments have been diluted to excess, they may lose some of their original colour, although in this case, of course, the fault will not be in the paper.

Rewarding results with unexpected brilliance of colour can be obtained by using

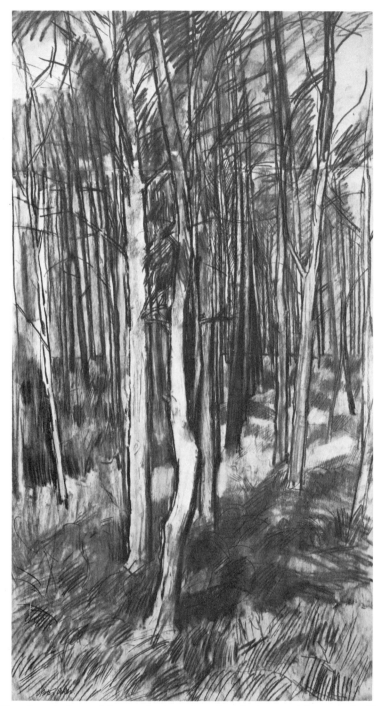

(a) Drawing study used for a subsequently painted picture on large scale. Vertical lines formed by thin lines of conté chalk, pen drawn ink shapes and tonal areas made by smudges of chalk and lightly drawn over tones of pale greys and black Peter Coker

34

(b) Detail of lower area of drawing (a). Note here that the tones of colour are accurately recorded and organised for possible later use by the artist of this drawing, although it stands in its own right as a completed statement and comment on the land seen

the cheap paintbox colours sold for children, but even the best quality colours will not last or look well on a cheap or unsuitable paper.

Stretch a sheet of paper (use large sheets in all these experiments) over a board, and bind the edges with gumstrip (brown paper tape), *Sellotape* or *Scotch Tape*. Pour water, paint or ink over the surface and then dry slowly by sun or artificial heat (a hair-dryer is excellent), and try applying colour at the various stages of drying. If, for example, a blob of scarlet is allowed to drip off the brush in one or two places, on some papers the colours will remain original in the dry areas and on others they will change.

It is a good practice to keep notes of these experiments on the paper itself, preferably in a panel left blank for the purpose.

The next test is for durability of surface. Try this on a tough paper, or any strong 'laid' paper. Scratch firmly over the surface with pieces of twig, match-sticks, ends of brushes, or fingernails. Then wash colour over the surface and see what happens when the colour rides over or settles on to the lines which have been made. This is almost a form of engraving on paper, and on some papers the linear designs so made will have much of the quality of an aquatint background over an engraved or deeply bitten etched line. This is not just a technical trick, because there are no rules as to how paper and paint should be used and the final manner of executing an idea rests entirely with the person involved.

Easels and accessories

Good, portable, folding, lightweight easels are supplied by reputable art dealers. Easels should be chosen carefully to avoid extra weight or complications in transport and use. An easel set up in a showroom looks remarkably simple; the same article on uneven, stony or wet ground may be tiresome.

For short working periods of an hour or less, an easel will probably be unnecessary, and a small portable stool essential.

Stools

A stool should be of light weight and a folding design (not collapsing – there is a subtle difference), with legs, rather than a bent metal rod for support, as this is far easier to make stable on uneven ground. A three-legged stool often proves invaluable on rough ground, but whatever type of stool is chosen it must be one that can be fixed firmly in the ground, as a wobbly stool makes drawing a nerve-racking experience.

Containers

Another essential item is a lightweight, strong container for bottles of ink, brushes, pens, pencils, chalks, etc. For safe transport, pack these items with kitchen paper to avoid jostling, as chaos will ensue if they are carried loosely. Water for diluting inks and paint and for cleaning is best carried in two containers; one can be used for storage and the other during work. Soft, plastic flasks or bottles are excellent

for this purpose and are easier to carry about if they are flat rather than tubular.

Brushes

Good quality brushes should be used for all media. Art dealers' shops supply a wide range of oil brushes, but watercolour brushes, suitable for gouache, water-colour or ink, tend to be either expensive or inferior in quality. Chinese brushes are strongly recommended for use in watercolour painting, but the directions supplied by the makers must be faithfully observed, ie care after use, gentle handling, protection of handles from water. Brushes are best kept in tube con-tainers made of plastic or cardboard; these may be obtained from the suppliers, but often similar material may be obtained from draughtsmen's offices and industries associated with printing and office equipment. Brushes may be carried in a holder made as follows: cut a piece of strong strawboard, 3 mm ($\frac{1}{8}$ in.) book-binding board or hardboard, about 75 mm (3 in.) longer than the longest brush to be used. Place the brushes on the card and secure them with two or three broad elastic bands. Slip the card into a polythene sleeve. This device will ensure that brushes do not rest on and damage the bristles during transport.

Chalks, crayon, and other single colour media

Some artists like to use a loosely bonded soft chalk which will make a coarse strong mark, or a broken and variable mark on a smooth paper. In using this medium, care should be taken in selecting a chalk which will not smudge too easily before fixing and which will either remain clear or dissolve cleanly when washed with water or other solvent when such an effect is *not* required. Sometimes a soft pencil – 6B or 4B – will give the appearance of a chalk drawing. Pencil has often been mistaken for chalk in description of work, and the only way to solve the problem of chalk quality is to try out as many varieties as can be found.

Crayons can be used in exactly the same way as chalks but if they are oil bound they will to some extent resist water and require careful fixing with a good brand of fixative. Instructions for use are always given fully in the trade range. Some artists like to work with wax crayon in order to make the surface or line resistant to a wash of gouache or watercolour which may be applied later in the working. Crayons can be worked one over the other in several colours but if a first layer is put on too thickly additional colours will probably not cover successfully. These may be laid alongside a major colour, working in a manner of expressionism in which, for example, a yellow and a blue would be placed adjacent in order to produce a green whereas a scarlet line between the two colours would tend to brown the quality of the colours.

Charcoal is a smooth and benign medium flattering to the artist, facile in use and requiring fixative spray treatment if the work is to be kept. Sticks can be made from slow burning soft woods at the bottom of a garden fire but are more easily

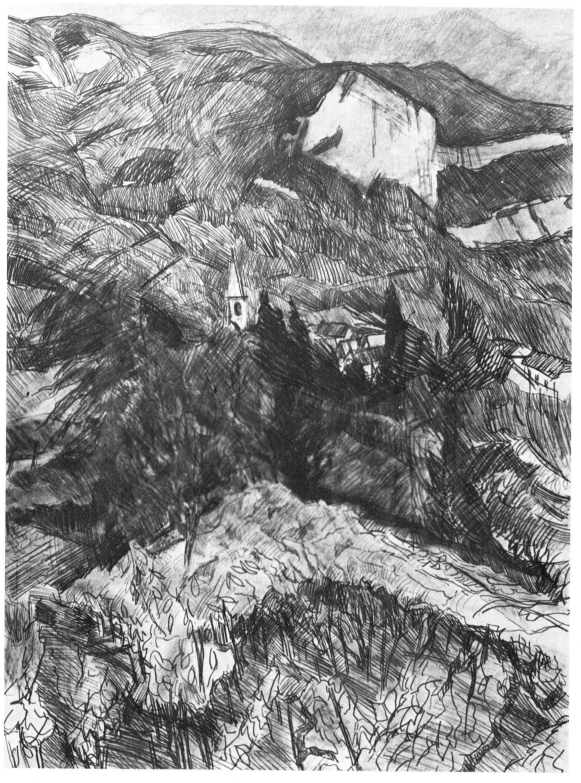

38

Mouthier-haute-Pierre by Peter Coker. Drawing with complete tonal scheme stated as a final existing image or a working study from which a painting or etching could be produced in later work. Technically this drawing shows a number of features so far described. They are

1 the use of pencil and chalk for original placing of facts into position
2 the use of tone of smudge or slight wash to clarify certain areas which contribute to the basic pattern of the picture
3 parallel or swiftly 'hand-curve' pencil and pen and ink lines to produce a tone and recession of plane in the image
4 the isolation of certain facts or items by additional white paint or removal of original drawing lines to draw attention to these selected pieces in the overall plan.

It will be noticed that the tones of the drawing are clarified to a degree which would permit close retention of the original shapes in a larger work made later from this drawing. Use of blacker tones and deeper lines leading into the centre has the effect of collecting the items into a central focal point almost as if a hole had been made in the paper and the shapes pulled through like a silk scarf, resulting in a final statement at the tower and steeple with evergreen trees in close contact

obtained through the trade, being supplied in sticks which vary from about half the width of a pencil to the thickness of a thumb. Thin sticks are better for pale linear work and solid broad pieces for making a quickly readable decisive line or a strong tone area. The edge of a thick stick of charcoal held near the drawing surface will make a crisp line and a delicate, less severe line if held by the upper end of the stick away from the surface, ie used as a Chinese brush.

Pencils

A wide range of quality and surface texture can be achieved by the use of standard trade pencils, ranging from very hard (H to 8H) to very soft (B to 6B). The hard leads act as a stylus on soft paper, producing a hard acid line, whereas the soft range produce an effect rather like chalks, giving a broken, dusty and rough line at 6B, so that the artist can make an area of thinly laid parallel tone with Hs through to a rich black area of loose graphite in the soft Bs.

For sketch notes, pencils of HB, 2B, or 3B will be quite soft enough for general use. If 4B or 6B are used, the effect will be similar to that of chalk, and in this case working should be as clean as possible in the early stages, as rubbing and general deterioration will eventually occur. If the artist wishes his drawing to remain clean, a protective fixative spray must be used.

With the addition of a medium, eg thin oil, white spirit turpentine, water, pencils behave very differently. The very hard lines will plough into the paper, and these will fill with colour when it is added. The very soft range will smudge and produce a wash of a loose, gritty nature which will dry quickly on absorbent paper, but tend to separate and divide on a smooth or less absorbent surface, eg paste board (a trade made card with prepared working surface), coated paper that is primed, eg with a coat of emulsion paint or decorators' colour; thin white gouache or any surface material rubbed on by hand. Oil or water colour will break up the pencil surface in the soft range and run over whilst not completely concealing the medium in the hard range. If the obliteration of earlier work is required, then naturally a thicker layer of gouache or other obscuring pigment should be put on the surface.

Pencils have the advantage of easy transport and storage, with completely reliable performance at any time in any conditions of temperature or humidity. Obviously hard pencils will tear thin paper and destroy delicate Japanese papers. Only experiment will help the user to decide what type of paper is suitable for the work in hand. Soft or delicate papers can take one or two applications of a surface material such as gouache and will receive a medium hard (HB) pencil line without damage; in fact, with a quality which may prove a pleasant surprise. Pencil drawing is not flattering, and will reflect the experience, patience and mood of the artist more than any other medium.

Experiment will show to what extent watercolour or thin medium will add information or clarify a pencil image.

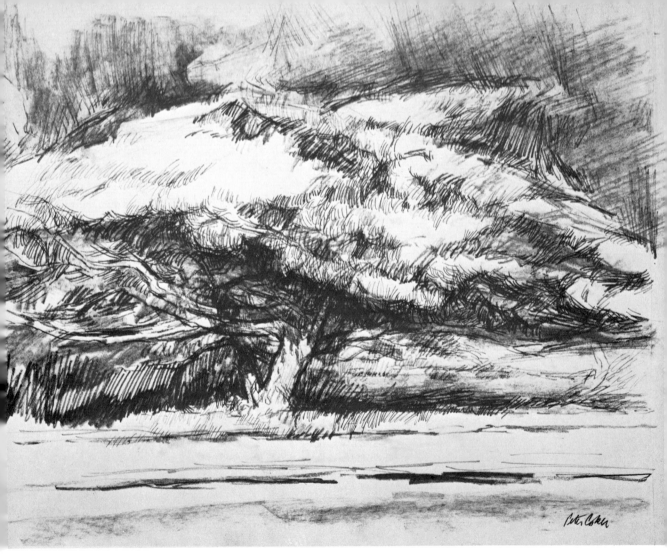

Drawing-painting, using chalk and pencil lines leaving light tonal areas on white untouched paper. Thinner lines in pen and ink and pencil define the form of the trees, branches and leaf masses. The umbrella effect of this tree is given emphasis by use of washed and smudged tonal shadows under the leafed branches. The road is shown by simple parallel hard surface lines in soft pencil and chalk to contrast with the rounded form of the tree

Working conditions

Some artists may not be distracted by the presence of spectators, but these, I imagine, will be in the minority, and most artists would be well advised to pay considerable attention in selecting a place to work, where they will be unobtrusive, and so be unlikely to attract observation and comment. It must be admitted, how-ever, that on very rare occasions, a local atmosphere and sense of occasion can be added to a landscape drawing by sympathetic observers who accept the artist's presence as a normal and interesting occurrence, rather than as a freak to be spied

upon. But beware of self indulgence. Walk away from the work from time to time, and come back to it with a critical eye.

Board or canvas can be rested conveniently on the ground. Paper should be clipped to a light board to prevent the movement which will occur if there is even a light breeze. Do not use drawing pins or thumb tacks, as they tend to become sunk in the board or tear the paper. If an absorbent but flat surface is required, the paper should have been moistened and stretched earlier on a strong rigid board, the edges of the paper fastened to the board with an easily removable adhesive tape.

If you wish to stand or walk about whilst drawing, make holes in the board at opposite corners and thread a string through them, and pass it round the neck, resting the near edge of the board against the hip.

Avoid leaving the working box in direct sunlight, and keep the palette covered with newspaper in the intervals of working, especially when using watercolour and gouache. The use of colour in brilliant light is something which can only be learned by trial and error. Pigments are after all, the same indoors as out, and it is only the dilution of colour and its selection which are affected by changes of light.

To carry a wet painting around, keep a piece of very thin cloth, crinkled foil or grasses, which can be laid over it, even under the pressure of another board.

The sketch book

A sketch book has two main functions.

1 It is the most useful way of keeping preliminary sketches for paintings which are to be made later in the studio. This is illustrated by a page from an artist's sketch book on page 49.

2 It is used by an artist when travelling in order to produce a set of drawings recording his experiences. These drawings will probably be signed and dated, and their location stated.

In either case the date and location of a particular drawing, and any notes added at the time are valuable, and serve as useful reminders later on.

The use of a sketch book for preliminary drawings is the subject of this section. Such a book is the artist's visual bank in which are preserved a series of drawn, or coloured 'notes' made to record an environment, a mood, a colour, a person or an incident. Thus, half-forgotten things emerge at a later date and often become the starting point of a much fuller statement.

It is as well to avoid all sketch books which are made of thick, unfriendly cartridge (heavy drawing) paper or handmade paper, trimmed and held together by a rubber composition, on a backcard of cardboard or grey chipboard. Every drawing on such a block will have to be removed whether completed or not, in order to allow the paper below to be used, and this makes the paper seem unduly precious. A book of leafed paper (preferably with a spiral binding) is very much better for a series of drawings, especially for casual or reporting work. Light-weight paper, bank paper (or thin writing paper) or light printing paper are all useful for drawing out of doors.

As a close companion, the sketch book must obviously be light and easy to carry. It should contain at least fifty sheets of paper, with a reasonably strong back which will stand up to constant use without falling apart.

It is most important that the paper should be of a quality, colour and weight which make it a pleasure to use. The response of the surface to the pencil, chalk, pen or brush must be immediate and direct. Often a young or inexperienced artist will unwittingly impose limitations on his work if he is not sufficiently selective in his choice of material: if the paper is not carefully chosen, it can prove an irritation or hindrance in drawing, thus defeating the whole object of using a sketch book.

Papers

Papers can be either transparent or opaque.

Transparent papers such as bank, strong detail and the tougher makes of typing copy paper are all good sketch book material. They are useful when adding note to note without redrawing an original image, as the first drawing will show through the overlying paper (often two or three sheets) especially with light bank paper.

Opaque papers include lightweight papers such as evenside, cartridge and litho offset which can be folded and cut to folio, quarto or octavo size.

It is best not to have too much size in the paper as it will be inclined to cockle when water is used in drawing. Avoid also the printing paper known as 'art paper' as this is coated with a synthetic surface which will not readily accept pencil or pen, and will, in fact, show an incised line from almost any grade of pencil in the 2B, 3B or 4B range. (An HB pencil is a good average for almost any form of drawing on any surface, but quality varies in different makes.)

Coarse-grained paper is not to be recommended for general sketch book use. It will rapidly blunt a soft pencil, and will rub and smudge very easily. It is also very heavy, and will thus reduce the number of sheets which can comfortably be carried on location. If it is used, an aerosol fixative will prevent the picture from smudging.

Composite papers A sketch book can be made of assorted papers, even including wrapping papers, in brown, grey, or any tint. These are useful in their variety of quality for quick or more leisurely drawing. It is unwise to use an inferior paper for notes, because although these are presumed to be of an ephemeral nature, they may some day acquire a more lasting quality.

Size of sketch book

It may seem unimportant to a beginner that a sketch book should be of a particular size and shape, but there are reasons why these things should be considered carefully.

Firstly, while a book may fit easily into a pocket, it may be too small for the type of observation and the medium the artist likes to use. A book which is slightly larger than a pocket size can easily be slipped into a waterproof covering, and will allow corners to be ignored or used according to whim. This suggests a size of 30 cm × 23 cm (12 in. × 9 in.).

Secondly, a larger book than this, say 38 cm × 30 cm (15 in. × 12 in.) or more, will require a backing board which will not easily crack or bend, and should, if

Photograph reference of near and reflected images. By the treatment of the print the tones here are even throughout and form a pattern, rather than showing any aerial perspective. It is as well to have a considerable number of this type of reference of one subject to relive the visual experience later

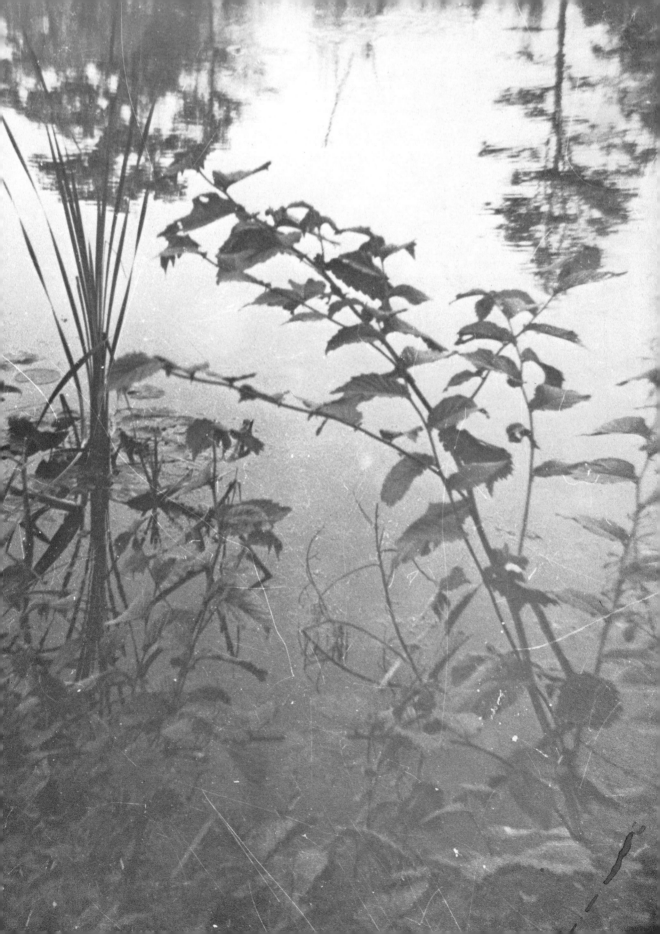

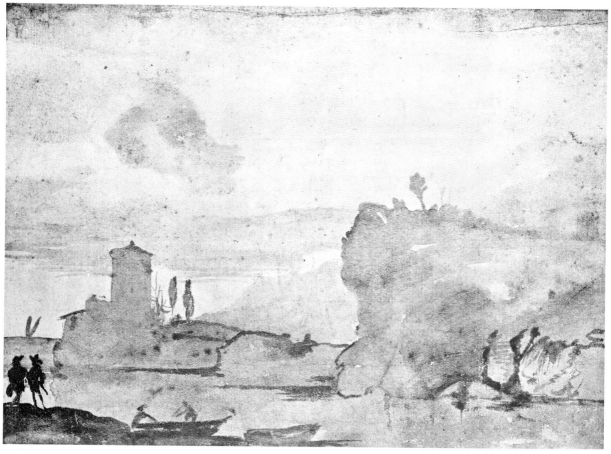

A tower on the coast from a sketch by Claude of a coastal scene in light colour and ink tint on rather rough paper. This demonstrates the simple description of a rock shape and cloud formation by emphasis on the tone and a clear edge to the colour.
The British Museum, London

possible, have a cover board as well to prevent damage to the papers. Layout pads sold through the trade are good for this purpose, but, again, should have an outside protection.

Thirdly, for the larger sized book, some excellent office stationery files with clips for additional papers make very good sketch books.

Artists' colourmen produce sketch pads consisting of several sheets of best quality paper, fastened in by light binder's adhesive. As the sheets can easily be removed after working, these books are useful as a means of acquiring stretched paper on a hard surface, but they should not be considered as sketch books unless each sheet when removed is clipped or pasted into a file.

46

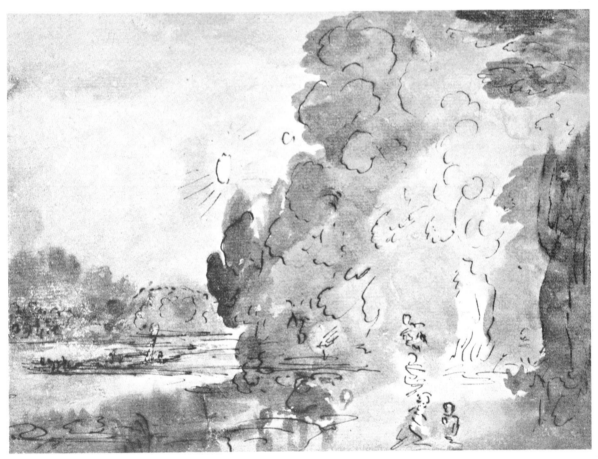

Nocturne from a sketch by Claude in pen and wash. The British Museum, London

Storage

A sketch book is a personal companion, and does not warrant great care, on account of its general ephemeral character. If, however, a slower drying medium has been used on certain pages, common sense will dictate to the user the required delay in closing the book before packing up.

Clearly only experience can help the artist to determine which type of book is most suitable. It is wise to date and locate each sketch book on the outer cover, for easy reference later.

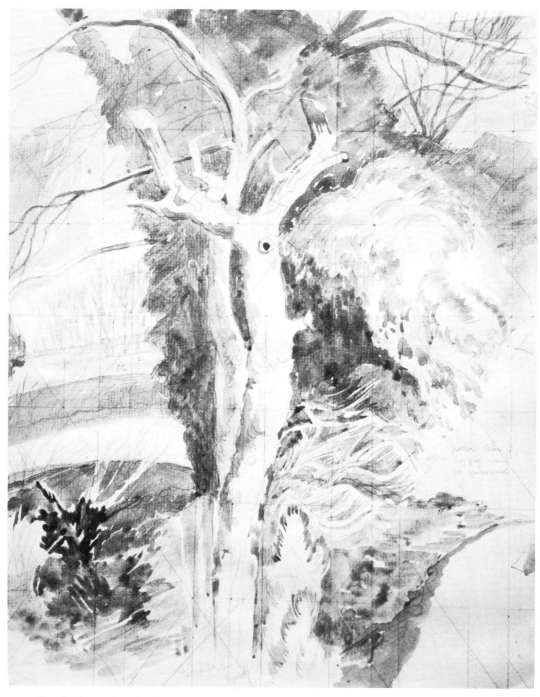

Sketch of tree slope by John Nash for his painting *Fall of Snow*

(Opposite) Detail from *Sheepfold* by Millet. Glasgow Art Gallery

48

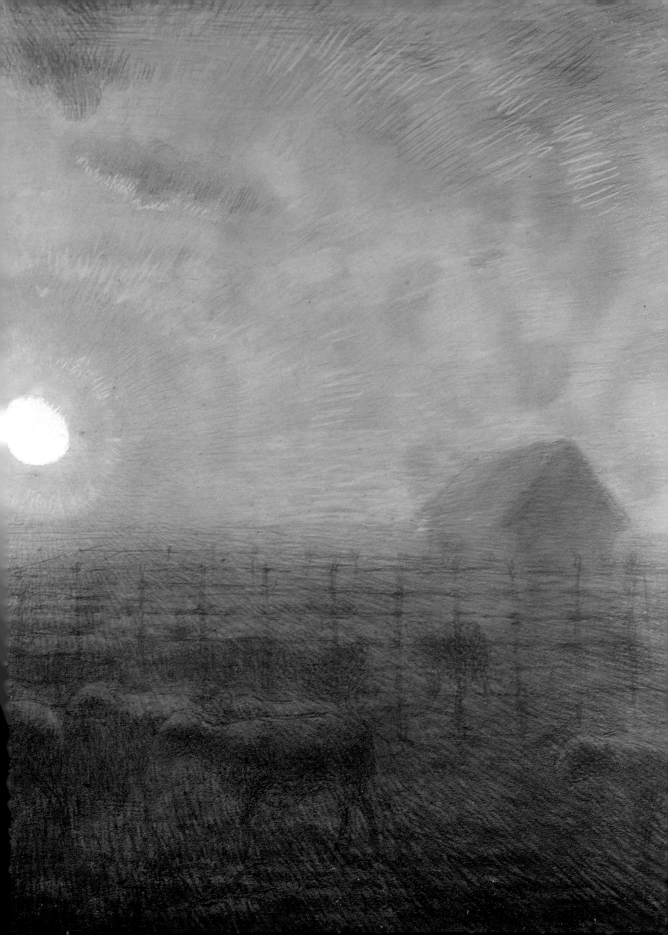

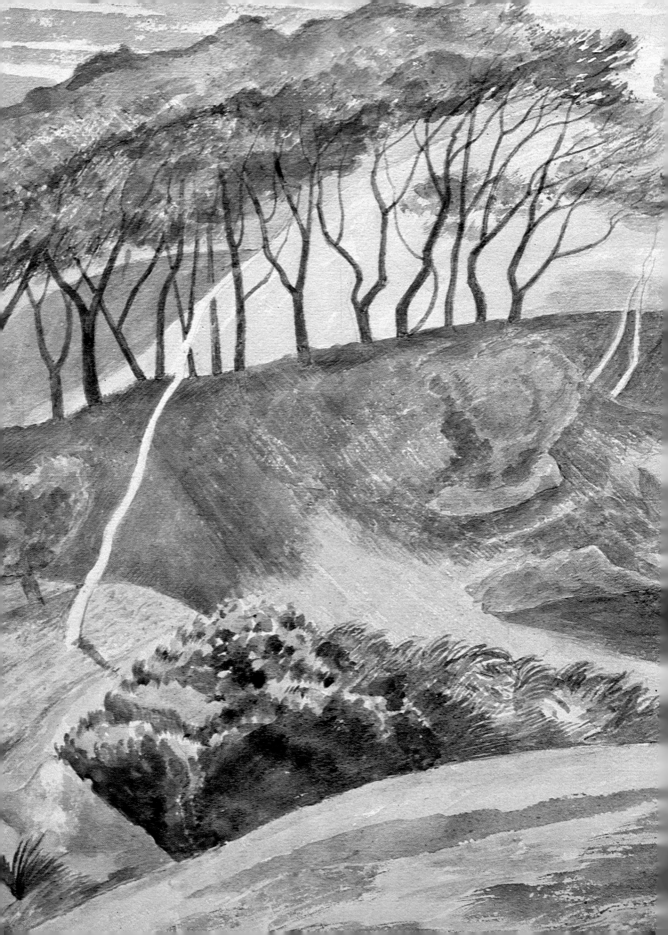

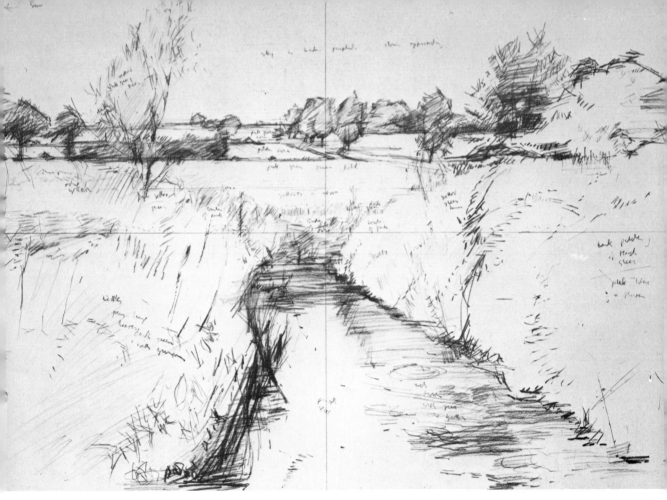

(a) Sketch book drawing with written notes for colours. Very bright tones left as clear paper. Used for a painting in similar pale tones Anthony Atkinson

(Opposite) *Trees on a Ridge*. Detail of final watercolour painting by John Nash. Here tones and shapes have been laid, untouched and only overlapping where a third or fourth colour is required. The painting was made from notes in a sketch book with colour notation, drawn on the Isle of Skye.

In the full picture, reproduced on page 88, it will be seen that a flow and sequence of near-mathematical progress in the trees supports the left and right movement in the composition. A tension is produced which assists the 'spring' of the ridge from which the trees grow.

Note also the absence of distracting marks which might delay or confuse the pattern and movement of the trees, sky, and grassy banks which are so characteristic of this artist.

It is interesting to compare this picture with the detail facing page 25 of Samuel Palmer's *In a Shoreham Garden*. In both paintings a clear design is stated; items are allowed to move within this order, loosely by Samuel Palmer, more rigidly and formally by John Nash.

The two painters, each intense observers of nature, have used widely different means of describing and organising the growing forms and details that are obedient to the rhythm they have dictated

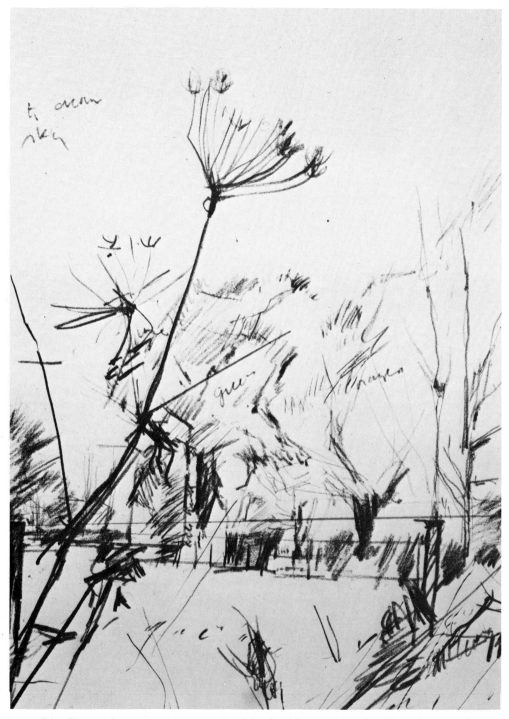

(b) Close and near notes drawn in sketch book with same intensity. Here, the general
line of composition is also shown by the horizontal, short vertical and long diagonal lines

50

Selection of image

The generally accepted range of vision for the human eye is around 60°, and a slight turn of the head to left or right increases this to 180°. This factor is not always appreciated in drawing landscape; thus the cone of vision produces two quite different aspects of landscape drawing, the first, an accurate recording of the thing seen, the second an interpretation of the scene, edited to emphasise some features and disregard others. This second approach permits rearrangement of one or more of the forms in the selected field of vision. There are absolutely no rules about this, and some artists select from material seen only, and work by exclusion rather than by inclusion.

It is the second of these alternatives which can be considered under the heading of zooming and cutting. There are one or two aids to this work which may be tried. One is the use of a card, into which a rectangular hole has been cut. The selection will be easier with two pieces of card, roughly post card size, one with a rectangular hole of 25 mm × 50 mm (1 in. × 2 in.), the other with a similar square opening. The two cards can be held one over the other and the aperture made larger or smaller as required by moving the square across the rectangle. Two pieces of blue tack will help to keep them in place.

As an experiment, stand in a landscape and hold the cards up to the eyes and pan to one side or the other through 360°. The resulting image is surprising as each item achieves additional importance through its isolation from its surroundings. With the card held in a more or less fixed position, a further experiment can be tried. The eye becomes a zoom lens, as in a film camera, which focuses on to a single area in a view and enlarges a small selected area of that view until it fills the picture area. In the small aperture, shapes and tones are accentuated when seen apart from the major area of vision. The place of colour in these areas may be of especial interest. An illustration of this fact is to look closely at a figure in, say, one of Lowry's North country paintings of a street scene, where from a distance what seems to be a monochromatic man in a dark suit will probably prove to have on close inspection, a red tie, checked jacket, a highly coloured face and blue socks. Apart from colour the appearance of tones will seem much more varied in the zoom. Passages of pale tint may be seen to contain other colours. The most ordinary horizon will prove to be more complex, and even a simple sea horizon,

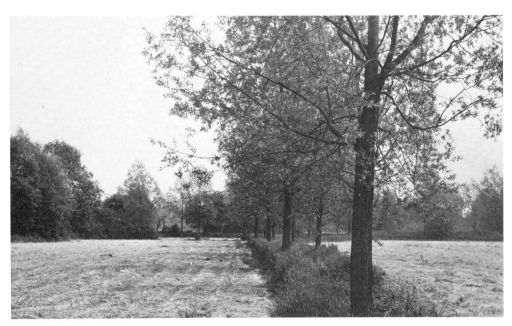

Photograph on location illustrating strong horizontal and vertical directions with a clear lead-in to the centre area from the foreground, following the line of trees. See the facing diagram for inset of zoom lens approach to this photograph, and if possible, isolate the area shown for experiment

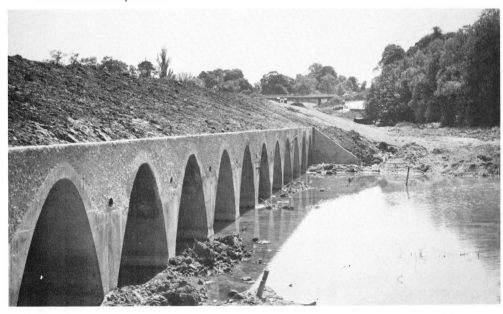

Photograph showing strong direction of the eye to the centre of the picture. Repetitions of arches and their reflections all accentuate the recession. Note on facing diagram the zoom lens area of this photograph in the square, which becomes a complete picture and a focal point

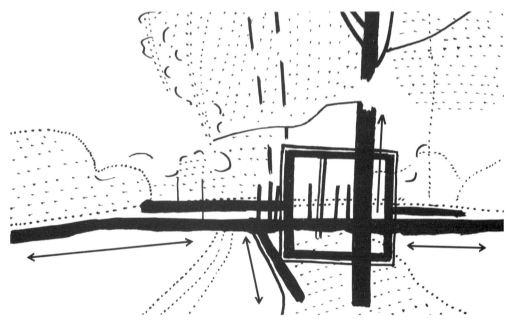

Diagram to read with facing photograph. Note dotted area to suggest all generally even tones supported by strong skeletal forms or directions, vertical or horizontal

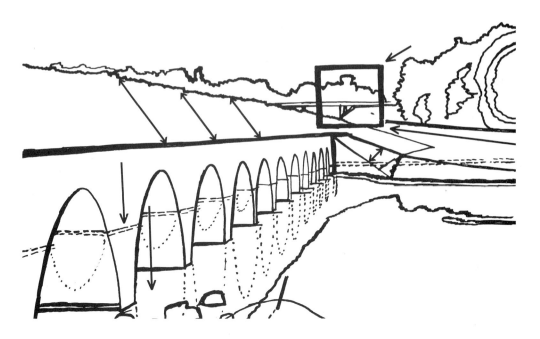

Diagram to read with facing photograph. This diagram speaks for itself, showing the movement of the arches and the angular plane of the banks as indicated by the arrows. Note the zoom lens section

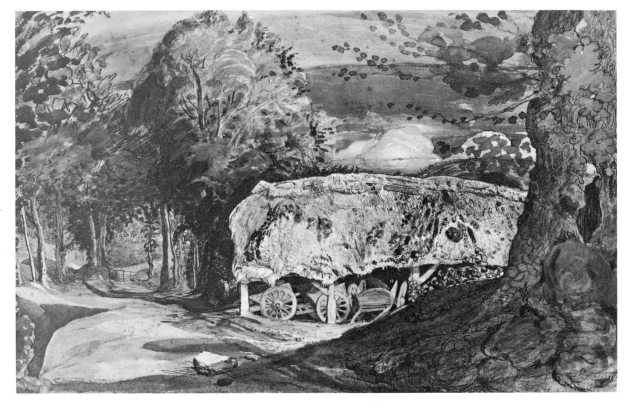

Lane at Shoreham by Samuel Palmer in watercolour and gouache. The eye is led deeply into the picture by repeated diminishing tree forms. Victoria and Albert Museum, London

whether there is a background or not, will be seen to have intensive variety in a range of 180°.

When an area in the wide angle of vision has been chosen, it can be enlarged in the drawing, discarding the view finder if you like, as the eye will tend to localise the area once it has been selected. Small pencil or chalk drawings made from this view can be enlarged by the eye or by measurement to make a new painting later on.

Enlargement can be done photographically or with a projector, but if this is not possible, the simple squaring process works very well. Place a piece of transparent paper over the sketch and fix it in position with adhesive at one edge. On this covering paper, divide the sketch into squares of, say, 100 mm (4 in.). Now mark out on the surface to be used for the new work the same number of small squares. Copy mechanically each linear area or strong line from the sketch on to the new surface. The larger picture will quickly take shape and follow very closely the movement and pattern of the original.

Landscape with Cottages by John Crome. Victoria and Albert Museum, London ▶

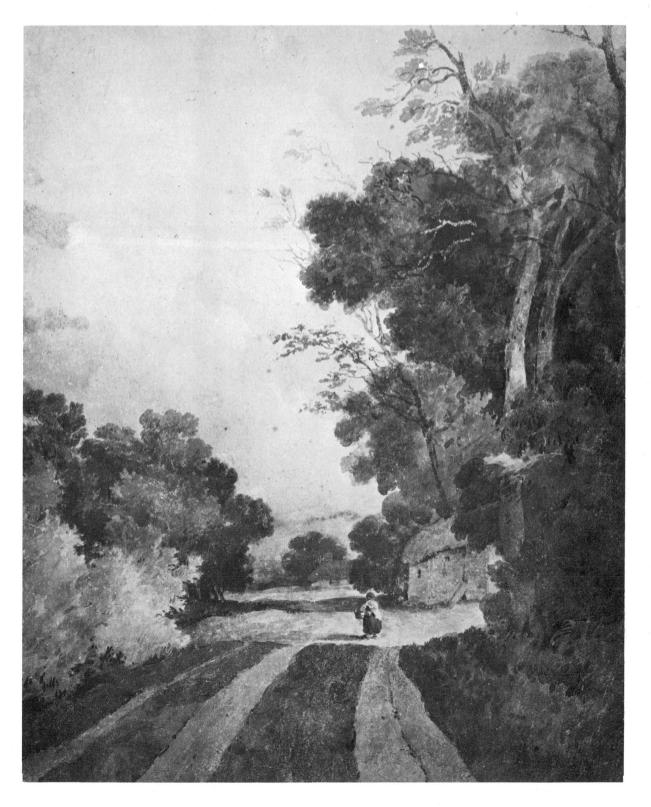

55

This method of enlarging is most successful in transferring a close formal design. For an artist who works more freely, using bold lines of direction, here is another method which may appeal. Standing or sitting in front of the new larger surface to be worked on, hold the sketch near to the face, adjusting the position until it is alongside the new surface and, with one eye closed, the same size in vision. With the free hand and a long brush or a piece of chalk attached to a stick, draw out the lines of the original on to the new surface. This same method can also be used with the new drawing surface on the floor.

After these guide lines have been drawn, the work of painting or drawing the new, larger image can go ahead in any chosen medium. Gothic painters used a similar eye process in planning and scaling an arcade, mural painting, or stained glass design.

Viewing nature selectively

Some artists when approaching landscape painting believe drawing and painting to be indivisible. In many of Constable's chalk and watercolour drawings, especially his quickly executed wash drawings, he produces a strong outline of an area of colour, and associated with it, a firm, descriptive drawing of growing forms. He has apparently separated mentally the cloud and tree shapes which he has seen so clearly, exercising his sense of draughtsmanship in making his statement about them, using line and paint to enclose the solid forms and foliage areas of the landscape, probably intending to use these same forms later in a major painting. For example, his painting, *The Cornfield*, in the National Gallery, London, has a tree at bottom left, simple in silhouette, forming two linear edges confining the bulk of a column. There are within this column a great many paint complications, mostly layers of colour, richly characterising the line, and quite unlike the surrounding grasses which have been given their own personality. Constable has achieved this contrast by drawing with narrow brushes the growth of flowering weeds and ripening wheat.

Samuel Palmer also exercised this personal selection, expressing so vividly in his Shoreham period his excitement at the discovery of the land itself as a subject for painting – the scent of harvest and the warm light of a rising moon. How much of his vision was the result of direct personal contact with the comfortable warm air of the harvest fields, and to what extent he became aware of the approach of the cool air of late evening is a matter for conjecture. The only evidence is in a few comments to friends and some recently discovered but as yet unpublished letters. We do know, however, that he was deeply moved by these elements, and that only

Cornfield, John Constable. The National Gallery, London. See also colour plate detail, page 24

56

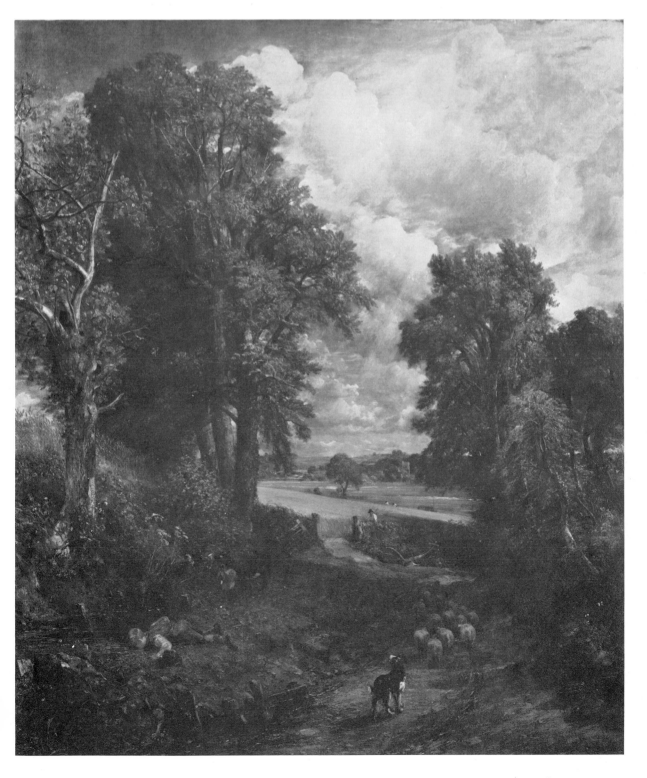

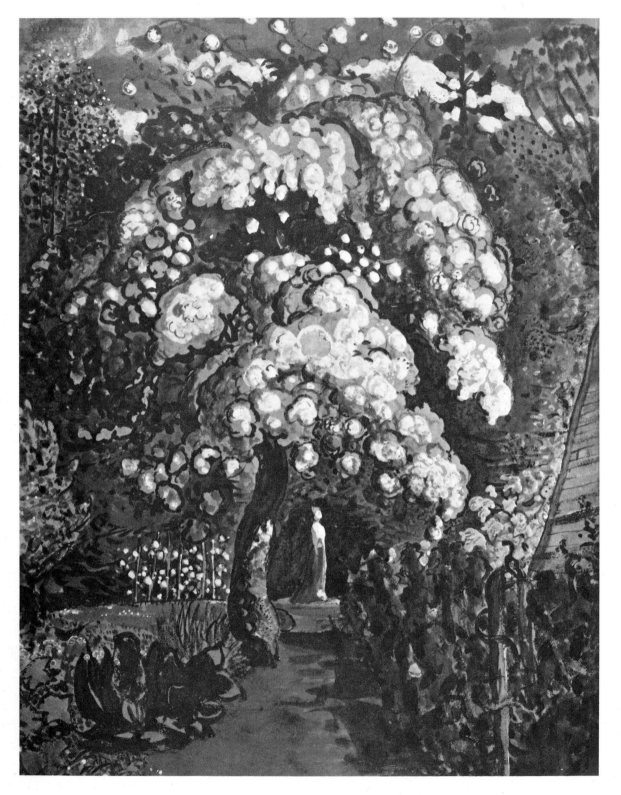

by half closing his eyes, or opening them very wide, against the full moon of mid-summer, could he experience the shapes and evocative forms which appear in his paintings and drawings. It is important to remember that Palmer, like Constable, had no camera, and only his eye could transmit through his hand the poetic reporting of a deep personal experience. Palmer certainly seems to have had some kind of built-in view-finder, and a method of subject selection rather like our modern zoom lens.

The zoom-lens principle can be used profitably by the rather more experienced outdoor painter. Imagine yourself looking up a straight road with occasional traffic. At the end of the straight section there is a bridge across the road, above which are some trees and farming equipment which invite closer inspection, but the traffic prevents it. Screening with the hands will help, or an aperture cut in a card will give greater emphasis to the shapes above the bridge. Drawing of notes in these conditions may be difficult, but continued observation and checking of the values of the shapes and colours should be possible, and at least some record can be made of the atmosphere and character of the distant place.

When the field of vision is confused or the material too close, the zoom principle will be useful – either a card with a cut-out viewing space, or simply the concentration of sight on to one small area to the deliberate exclusion of everything else.

It is a good plan to close the eyes occasionally, and then take one swift glance at the prospect. This may give the impression of seeing it for the first time and a new interest may be demanded by some hitherto unimportant feature of the place.

Ideally, the direct painting of the image, on location, is the most satisfactory method of working. Using good material in the selected medium, this may be the only opportunity of recording a happening. The drawing, in these circumstances, may well become a complete picture in its own right, so long as there is no question of 'dashing off a sketch', which is often a disguise for lazy working. Remember that an artist's notes are his own record of things seen and appreciated, and there is absolutely no reason why they should be made intelligible to anyone else. This applies equally to all stages of the work, in the studio and up to the finished painting. The artist must always act as his own critic and adviser, and he will know eventually if his recording is genuine or insincere. The honesty of his own personal vision will be evident in the finished work. Neither over-confidence nor excessive caution will add integrity to a work. A show of 'panache' will in fact reveal mercilessly any insincerity the artist is trying to conceal.

Many keen amateurs, in a desire to please or impress someone else, often spoil what might otherwise have been pleasant work. Sincerity is inevitably lost in an effort to express things outside the artist's own experience. The real quality of the work will be revealed unconsciously, and should persuade the viewer to accept the statement as it was intended.

In a Shoreham Garden by Samuel Palmer. Victoria and Albert Museum, London.
See also colour plate detail facing page 25

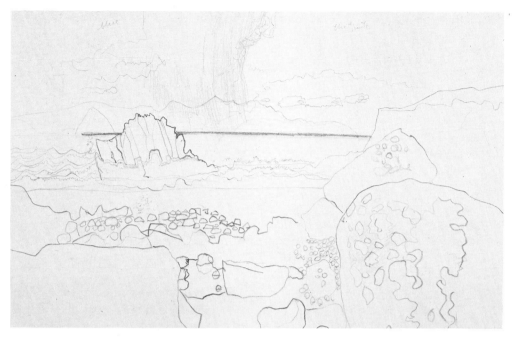

(a) Drawing. A landscape with rock forms and distant island, showing generally a wide image with similar emphasis on each area

(b) Drawing. The same location as (a). In this, note the island has been zoomed onto and made more important than the surrounding rock shapes, partly by application of tone and light colour, and by focussing the eye on to the central areas

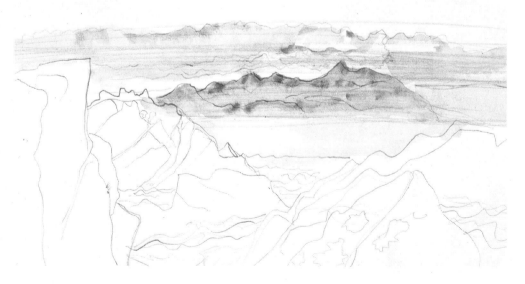

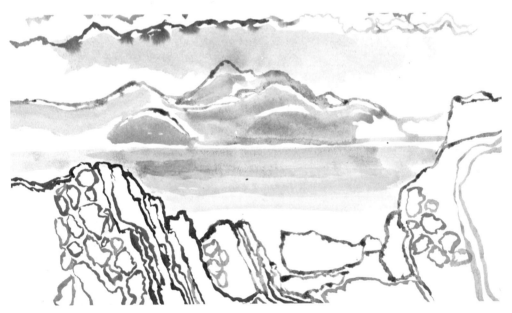

(c) Drawing. The same location as (a) and (b), zoomed more closely to the island. Colour has been added to the central area to give it more importance

(d) The island image as in (a), (b) and (c) in which almost total emphasis is on the island mountain silhouette, the band of sea, and the cloud formations which leave the island clearly defined

(e) The same image as in the previous illustrations showing complete extent of zooming, 'panned' to the right of the viewer, obstructing the island image by the near lichen-covered boulder. This leads to a different type of composition

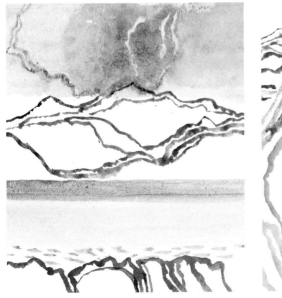

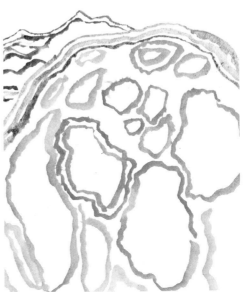

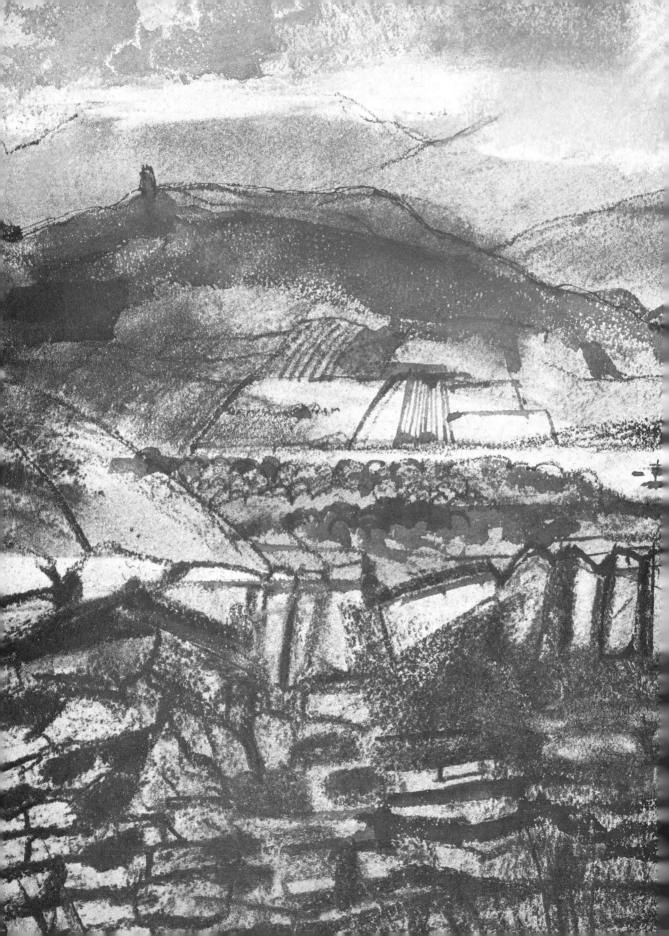

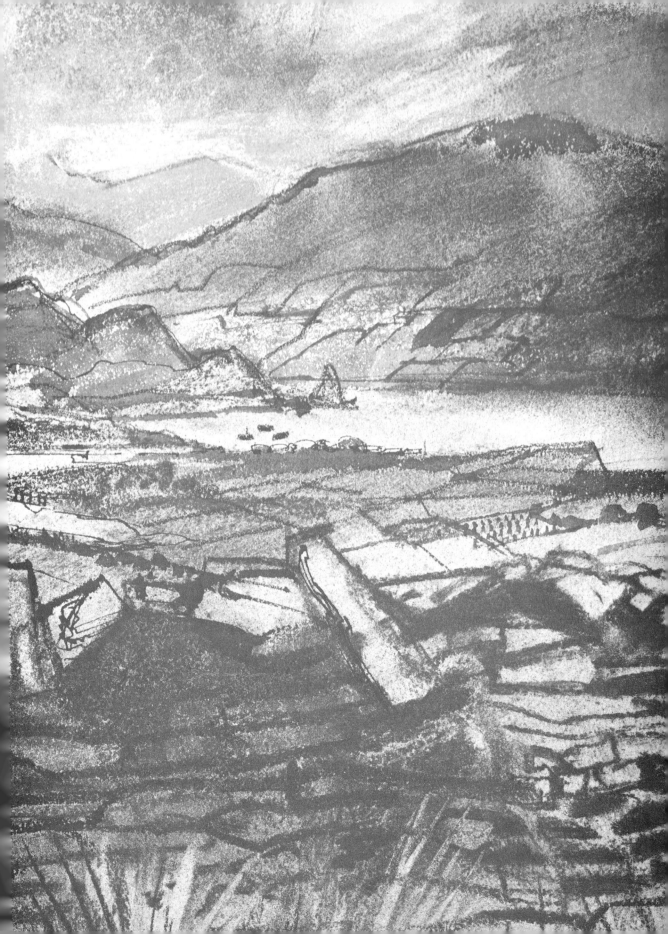

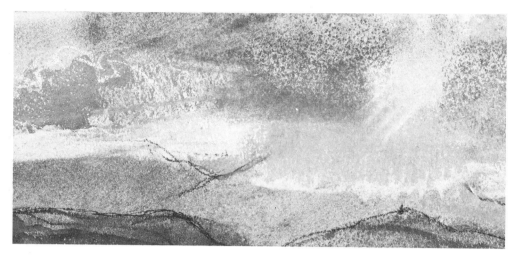

(a) (Previous page) Full prospect of estuary landscape with mountains. Made in ink and chalks, with equal emphasis on many leading features in the scene

(b) The same prospect and drawing as (a). The image here is localised to the estuary and distant mountains only, incidentally creating a strong central band in the design

(c) A much enlarged area from the previous drawing in which the picture becomes a comment on cloud with only a suggestion of land, and giving a different concept from (a)

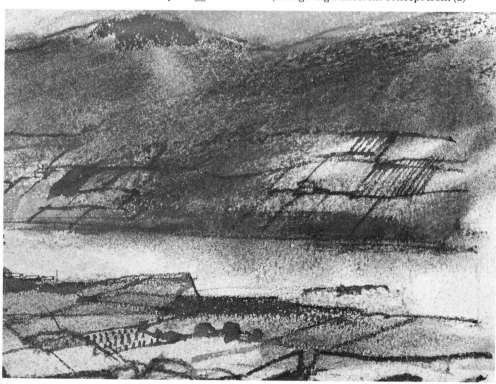

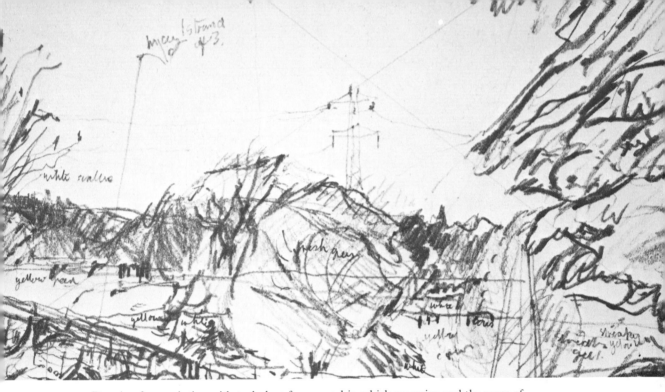

Drawing for a painting with turbulent foreground in which recession and the sense of space are forcibly impressed on the viewer by pylon cables and airlines. From this drawing a smaller zoomed image might be made from the area above and below the central pylon

Olwyn Bowie

Stowe Road by Elizabeth Sorrell. Painting in which the foreground is extremely important, and in which the artist has shown more interest than in any other part of the picture. But here the accurate portrayal of the local landscape is essential in supplying the character which the whole picture achieves; therefore the two parts are inseparable

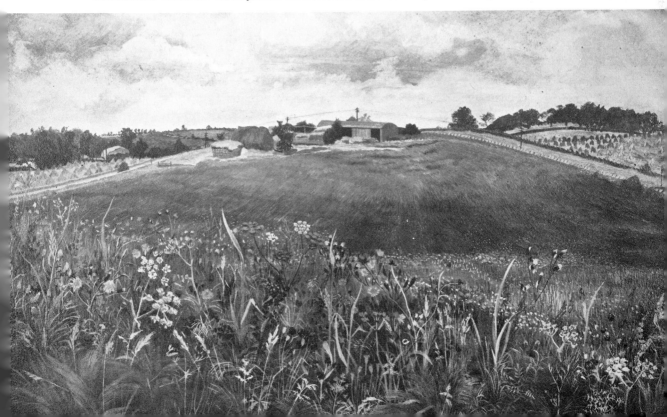

Seasonal and climatic changes in landscape and industrial land

Land images change to an extent which is not always appreciated by inexperienced artists. For example consider a large field with low hills around its perimeter and a corner of marginal land. At the end of summer when the harvest, bracken or grass has been cut and removed, the taller weeds have rotted and some ploughing has been done, the land level will be at its lowest stage for the year. As spring develops the land will change its profile and strongly defined gullies and minor ridges will disappear in the unity of new growth. At peak height, crops, grasses, shrubs, etc, will have created a land form and contours well above the winter level and some landmarks which were prominent in winter will be concealed beneath this new growth.

In valley land the effect is similar to that of flood water rising and making islands of higher ground. Although this may seem an obvious seasonal change, it is rarely appreciated as a problem in landscape drawing. Obviously an artist who is familiar with the place will be able to recognise partly obscured landmarks. Hedges and walls will be reduced by the new height of grass and corn. To experience this mobility of the land the artist should select a place where such a change is due to take place rapidly, for example a field or shrubland site which is due to be cleared for building, a drainage excavation or trench digging for domestic or industrial services. Here he should make some drawings over a period of a day or two, returning to the site as the alterations proceed. In the case of an excavation there will of course be the additional height of thrown up land as well as the cavity itself. It is best to select a small area of land about the size of a tennis court in order to study these changes, making each drawing from the same position. One basic difference will be that of surface texture; the light flowing quality of grain and shrubs will give place to coarse gravel, clay, rocks or sand. Vertical facets will have appeared in the hollows and in the sides of mounds of earth, rock, etc. These facets will have reflected surfaces which will be a new quality and interest.

Drawings of industrial land are best made over a period of time and if the artist is able to stay for a few days in the same locality, he will find great changes, for example in opencast workings, mining areas, manmade industrial water courses made by the change of light, smoke, hill mist or fog, rain, dust-coloured low sun or waters lit by dawn light or moonlight.

66

It is a mistake to assume that industrial land can only be recorded by a tough drawing technique on account of its technical nature. Frequently a light clean linear pencil drawing with little tone or pattern will give the required reminder or portrait of the location. If the drawing of smoke, storm or fires, for example is accurately made and the physically stable items are drawn in a similar way, the fact of working under changing conditions will give a sense of urgency to the drawing which will thus become more evocative of the place. A tonal smudge of smoke cloud, the reflection after rain of wet surfaces and the passage of swiftly moving materials on the site can be shown in a matter of seconds. Without a close understanding and recording this atmosphere cannot exist in the drawings. This does not exclude the concept of an industrial site in which only the atmosphere and local disorder is recorded. See notes on figurative and non-figurative imagery.

Work done on location at an industrial site may require mobility from place to place, and then easily carried materials are essential. Weather conditions, including such hazards as wind change, mud or dust may seem more troublesome in an industrial setting on account of the unsympathetic environment than in a quiet and peaceful rural setting, but the problems of mood and changeability apply equally to both.

Try to see an area of land sometimes as a stage, peopled with actors or dancers and stage scenery. A low morning or evening sun will translate the familiar colour, shape and special emphasis into something new and strange. This temporary 'theatre' can be recorded in drawing as well as a full painting by using media which will show quickly the difference between, say, a sunlit hedge or wood and a similar area in morning or evening shadow, and speed of notation will be essential to avoid failure. Each 'occasion' should be considered new, original and fugitive, and treated as unique and unrepeatable. This condition often applies in the visual arts, whether in recording a nude figure, a rural situation or a portrait of a location. Either the artist will record the solid facts of a subject, its structure and form as opposed to atmosphere, or he will attempt to state the mood changes or physical feeling of the location.

It is true that a sense of place cannot be expressed to the full until that sense has been fully explored, that is, until the painter has known the comforts, discomforts, sensuous quality and/or unyielding nature of the land. To be too wet or too hot, too cold or otherwise disturbed in working conditions is an advantage in this context.

One of the most obvious changes in landscape as already mentioned is the full growth of a wheat crop which has raised the ground level very considerably, and the immediate loss of depth down to ground level when the grain has been harvested. In the diagram this is obvious but less easily observed in the two photographs taken at Layer de la Haye in Essex where a lowering of some three feet (90 cm) has been experienced. To experience the full effect of this change of land level which, unlike the rise and fall of sea level or river in flood is not likely to recover for eight months (if cultivated), one must be in the field and aware of

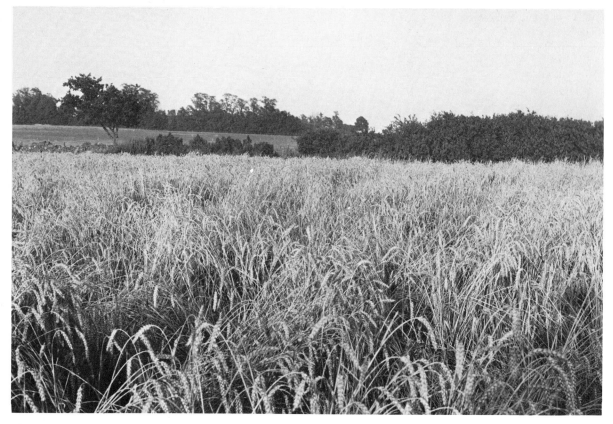

(a) A cornfield in which the foreground is raised considerably by growing wheat out of which the far hedgerow rises

(b) The same place as (a). The hedgerow grasses and the line of the field can be clearly seen as the foreground level has been reduced three metres by harvesting

(c) Photograph of same field as (a) ploughed and levelled. Note the trimmed, unleafed hedge is now very severe, and the distant tree line is a new interest in contrast with the hard flinty foreground

insect arrival and bird life, the scent of newly exposed earth and cut corn, all of which add, perhaps unconsciously to the degree of acceptance of the sense of place.

Cloud forms and movement and colours of clouds can form a major part of a landscape. This is especially noticeable when a large and clearly defined cloud mass echoes a similar shape on the ground. This often occurs to a remarkable degree in hilly country when low cloud is moved by currents of air round the tops of the hills, changing a major parallel direction of cloud to a wave movement which repeats the contour of the hill. Should this pattern form a reflection, there will be a greater repetition of rhythm. From the picture point of view this sympathy between cloud and land mass unifies an image if only for a few moments early or late in the day.

68

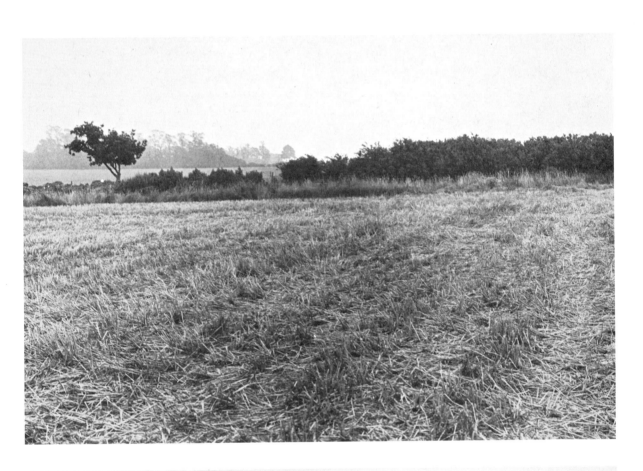

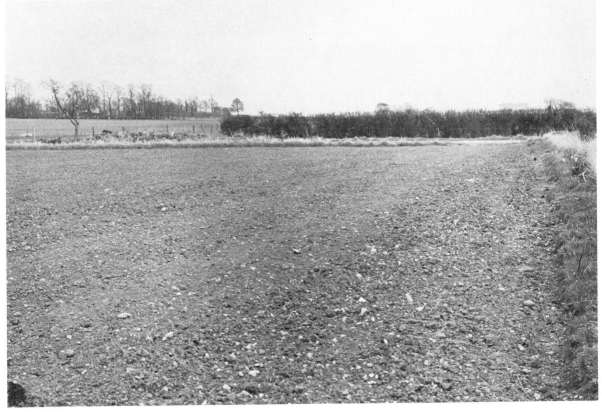

(a) A corner of a cornfield in which the crop is concealing the groundline. A similar obliteration occurs when a landscape is covered by several metres of drifting snow

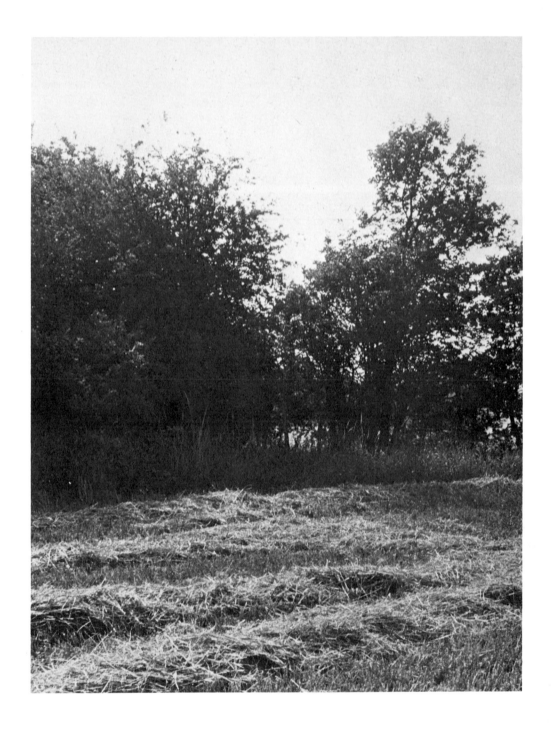

(b) The same field as (a) after harvesting, in which a new quality has occurred because of the stubble and straw in the foreground, which is now about a metre lower after cutting. The groundline and the grasses in the bank can now be clearly seen

(a) Diagram of a landscape suggesting ploughed land in the foreground; the winter hedgerows are clearly visible on white thin snow or a light covering of frost

(b) The same as (a), suggesting corn, clover and other crops, growing to a height of a metre, covering low hedgelines completely and isolating trees and shrubs

Rhythm in landscape

There is an underlying rhythm in most land images which is sometimes immediately obvious, but is more often of a subtle nature, not easily revealed to the casual observer.

When drawing landscape it is important to search for this rhythm, which can often be best recorded first in a drawing medium, as this will offer a clearer pattern which can later be followed through in another medium. In discussing 'drawing' in this context, I include drawing direct with paint.

The drawings on page 84 show the movement and swing of a small tidal beach on which the edges of small ridges of sand record clearly the ebb and flow of the waves. Seaweed and other tidal flotsam stay in position behind the receding tide in exactly the same rhythm as the sand ridges. The shapes of standing pools of sea water conform to the larger movement of the high tide lines, together with rock shapes and banks of sea grasses.

It could be argued that this rhythm will appear in the drawing in any case by reason of accurate observation, and this may well be so, but it will be of considerable help to the less experienced painter if he can select and report these shapes very quickly, at an early stage of his drawing.

In the illustration on page 60 similar flowing lines occur in the relationship between a low hill near the sea, and a man-sized boulder in front and nearer to the eye. In the diagram on page 61 the silhouette shape of the rock echoes that of the boulder which has been rounded and polished by the sea. Small captive water areas beneath and in front of the boulder again echo the line and strength of the small hill. Each of these shapes follows a clear sympathetic rhythm, and it would be reasonable to draw both by a similar visual process, namely by the linear or tonal enclosure of their mass, regardless of scale and actual distance in aerial perspective.

A similar movement of line can be seen in the tangential contact of two curves or in the enclosure of one form by another, and this is helpful in the selection of a sequence of shapes for use in a drawing or painting. This sequence of shapes may be in very small units and assume only a minor role in the order of the composition.

Sometimes, one of these small sections may set a pattern for the remainder of the work and can be repeated over the picture by a subtle re-use of the same shapes.

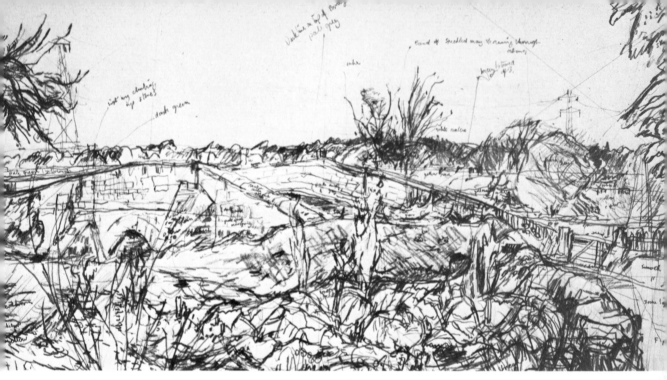

In this drawn study for a painting, the design is clearly retained throughout the notation, moving from the rough wall surface on the right in an arc over to the centre across the bridge form and out at the left where pale green and brick colours are indicated in writing. Notice in smaller items, eg the curve of the tree branches upper left, similar shapes in the grass in the foreground and the tree silhouette edges in the distance, the same double curved movement has been observed and used by the artist Olwyn Bowey

A similar use can be made of ground plane forms receding in vanishing perspective, ie corrugation on a sea-shore or planted land, scattered boulders, crops or other growing forms. In this case, optical perspective, recession and changes of colour and tone will be seen together.

In the reproduction of Millet's painting, *The Sheepfold*, the moon is an obvious focal point and concentric circles move outwards from it into the rest of the picture, bringing in line the direction of the sheep, the cloud formation, and even the raised hand of the shepherd.

The rhythm of land is just as strong, whether the edges of forms make curves or rectangles. Built structures and rectangular rock forms can suggest a movement of the eye from edge to edge, travelling inwards into the observed area and returning to the nearer surfaces at another point in the landscape.

Another kind of rhythm is made by the recession of planes crossing from side to side and each assuming a separate colour or range of colours. Sometimes this sequence will follow a similar shape in recession, at a further distance on plan into the landscape, eg a series of rock forms, shrubs and trees, or hedges receding into the distance.

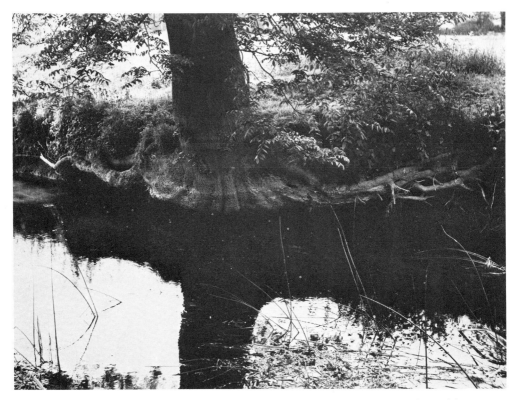

Photograph on location of a tree and its reflection in a stream. The swing from side to side of both the river and the flowered bank is the most obvious feature here. Sudden violent interruptions to this swing by the vertical tree and its reflection make a cross design which is modified by the gentle downward rhythm of thin branches and their leaves. An interesting interruption in this image is the thin linear reed shapes with their reflections like counterchange scratches right and left in the water

Rhythm in reflected images

When drawing a reflected image, the rhythm and flow of the shapes are seen to be similar to a dry image, but repeated in a receding plane below the mirror surface of the waterline. For example a prominent landmark in a hill range contour may not be recognisable in the mirror image as it will be screened by nearer hills not previously noticed in the original, and the top silhouette will have changed, as only a slight deviation is required to discover a fresh profile.

In a small area of water without any wind, there may be 100 per cent reflection to such an extent that with half-closed eyes the whole image would appear to be held in space. A light breeze breaking up a water surface will destroy the reflected image and leave only the original land forms on a 'solid' plane of water.

The diagram on page 85 illustrates objects in the field of vision but not seen in the reflection. Repeated form of the land in the reflection is equal at water level if it is imagined that the waterline continues under the land. Notice that the highest

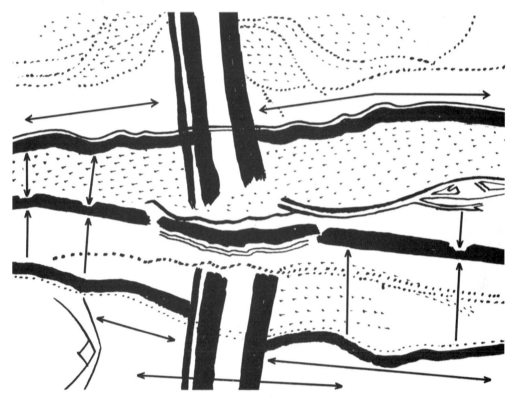

Diagram to facing photograph analysing the rhythm shapes as described. Note, even in diagram form, the isolation of the reeds as a unit of design

peak is not seen in the reflection as explained in the section diagram; the sun also is not seen. Naturally a raising or lowering of the viewpoint on the river bank will allow vision, or obscure from vision, the highest points whereas the near, waterside features remain almost unchanged.

A practical illustration is to invert half an orange in the centre of a small horizontal mirror. Holding the mirror to eye level the dome of the orange is seen clearly in the fruit but will not be visible in the reflection.

Rhythm in landscape can be of an interrupted nature, for example in the photograph on page 82 of a new motorway. The principal direction of lines may be seen in the diagram on page 83 moving from L to R towards the bridge, and up and down the lower areas of earth, interrupted with a 'shock' stop by the vertical lines of the scaffolding and the regular discipline of the parapet. The central tree in the illustration on page 80 makes an emphatic interruption, eye lines move from left to right and up and down, meeting at the vertical tree form and the edge of the water and tree reflection. This photograph shows a location of detail within areas of the place, such as the reeds in the foreground and the leaves on the edges of the twigs, which have a Pre-Raphaelite quality. A look at a painting such as Millais'

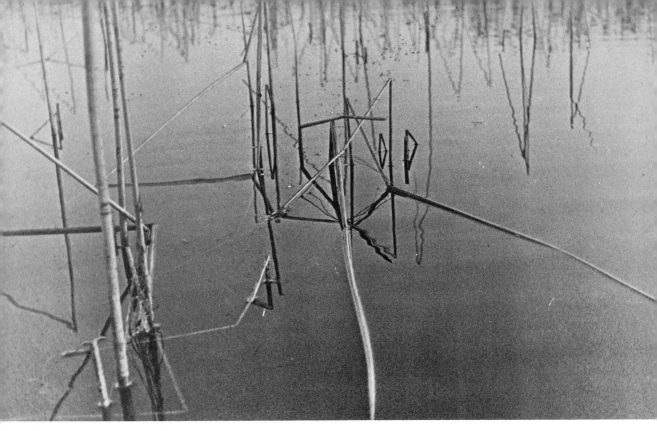

In these photographs of details of reeds with still or slightly moving reflections, it can be seen that in (a) the design is spiky and wiry, whereas in (b) and (c) the movement of the water has already produced a vibration like a graph reading in the reflections, variable in intensity, producing a rhythmic order in their disturbance in the centre. The wholly disturbed foreground reduces the reflection to quickly moving vibrations across the image, leaving the original static and undisturbed

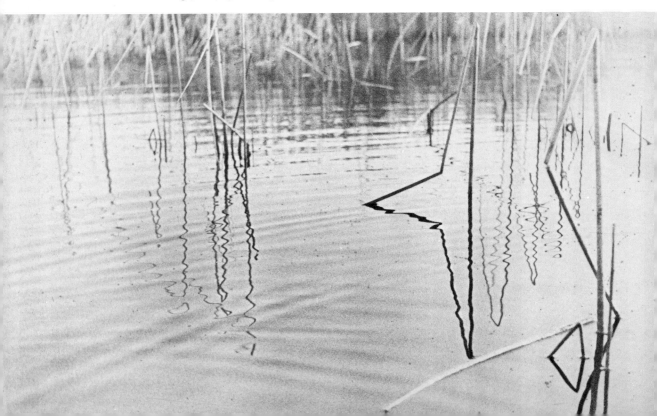

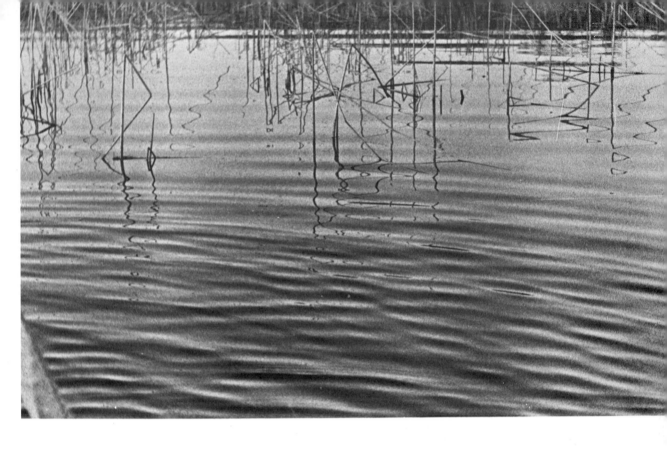

Hundred per cent reflection, entirely destroyed in central area by swift movement from
side to side

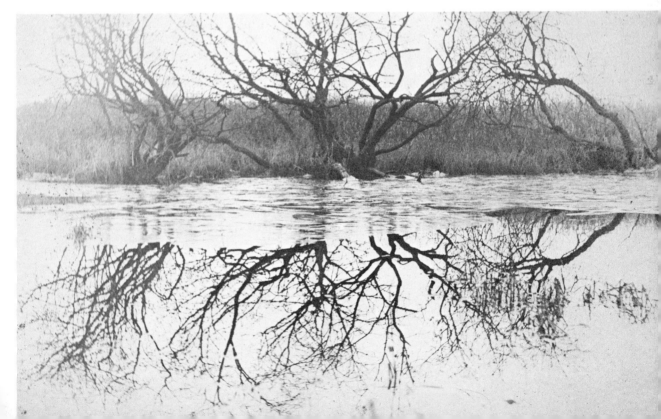

In this strident vertical interruption to a horizontal landscape an intersected type of design is clearly seen. But for the curve from bottom left to right lower centre, this image would be practically four-square

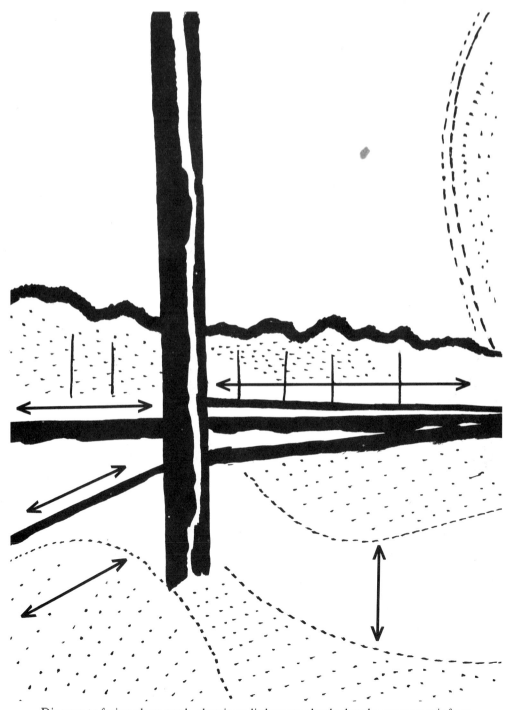

Diagram to facing photograph, showing a little more clearly that the movement is from left to right in the middle distance and moving in several directions in upper right margins and foreground weeds

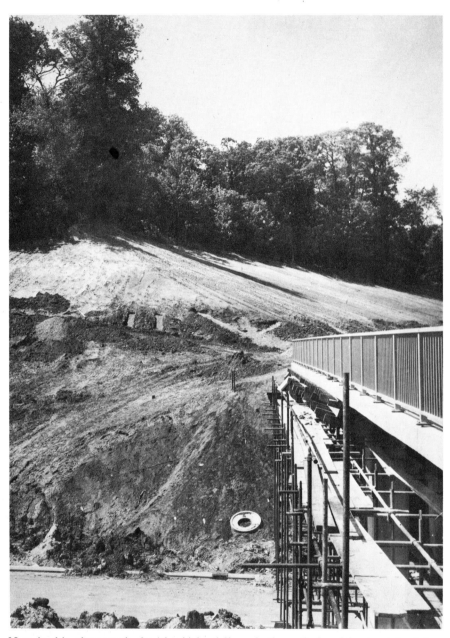

Note in this photograph the 'shock' hard lines, both vertical and horizontal, of the motorway surface and the bridge, butting into the flowing lines, natural and manmade, in the embankment. The tree forms, undisturbed by the engineering would be constant, whatever further growth or development took place in the foreground. This photograph will remind us that particularly in areas of community living, landscape can be changed by man and machines to a degree greater than that which is generally understood, and features which were thought to be natural and undisturbed were in fact manmade several thousand years ago, perhaps for thirty to forty centuries. Modern machine

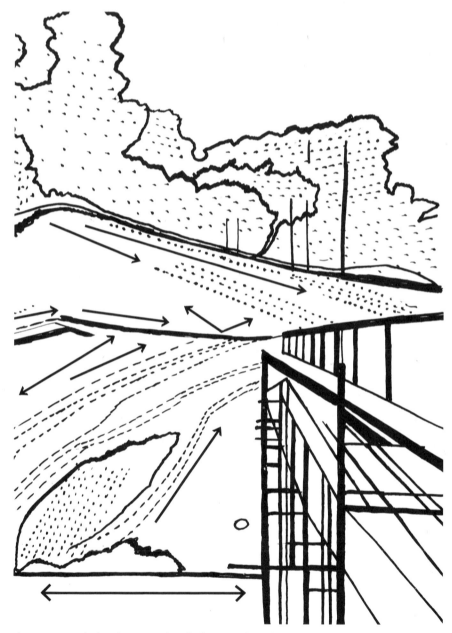

changes are obviously more drastic but can be of great interest to the artist. This particular photograph is in Constable's Dedham Vale where the trees which he painted have disappeared but new ones have taken their place and are receiving the same light which made them exciting to him

Diagram to facing photograph, emphasising movement of earthwork and irregular static profile of trees and the hard interruption of the environment by the bridge

Pencil drawing of headland rock form, noting curve and movement of silhouette and structure of rock

Tidal recession and movement noted in front of rock form of the previous drawing. Shapes of curves are similar although in water, to those of the rock itself. This is notice-able where the water is running into pools or wearing holes into the soft banks of hill streams. Perhaps the most outstanding example of this sympathy of rhythm is constant wear into recent rock which forms a pothole from constantly flowing water. Compare the similar movement of cloud forms by air currents taking their shape from the profile of a hill or mountain

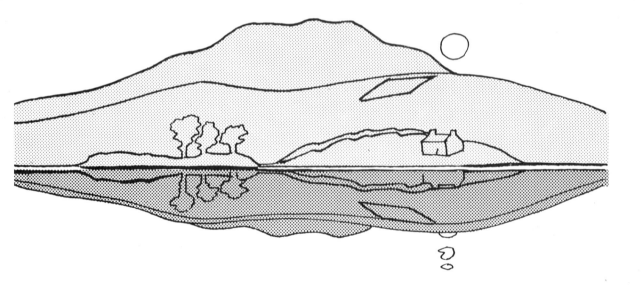

Diagram showing objects seen in view but not seen in the reflection by angle of vision. Repeated form of land in the reflection is equal at water level if it is imagined that the water-line continues under the level. Notice the highest peak is not seen in the reflection, as explained in the diagram of the section. The sun also is not fully seen in the reflection. Naturally a raising or lowering of the viewpoint on the river bank will allow or obscure more of the distant items whereas the near waterside features remain almost unchanged in view

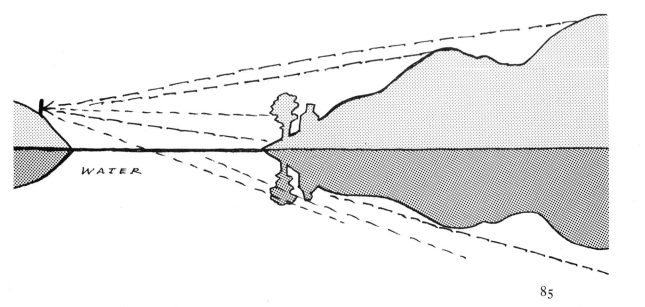

WATER

In this drawing *View of Tivoli* by Claude the gentle curve from upper left down into the centre of the picture area among the flowers, pausing and swinging again out of the picture at lower right, has a strong rhythmic character. These lines are contained by the upward curve of the hill shapes in the foreground and the downward movement of the mountain. British Museum, London

In this stylised drawing by Claude the tree forms are drawn with gently curving quill lines over the general direction of branches, following so closely the flow and rhythm of the leaved stems that the movement of wind across the trees is clearly sensed. We feel here that if the wind dropped, the artist would have drawn the trees with a different direction in their movement. It is interesting to compare the formal tree draughtsmanship here with the much more emotionally expressed trees in the Samuel Palmer drawing shown on page 58. In the Palmer drawing, too, the highly energetic cloud movement in the distance is seen in the same tone and as part of the same pattern as the trees in front of it

Detail from *Ophelia* by Millais. The Tate Gallery, London

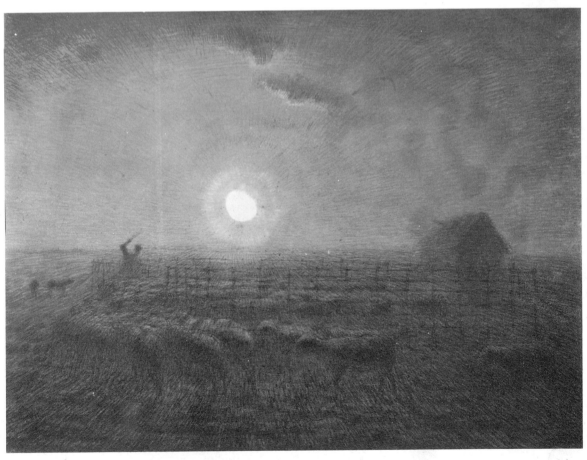

Sheepfold by Millet. Glasgow Art Gallery. See also colour plate facing page 48

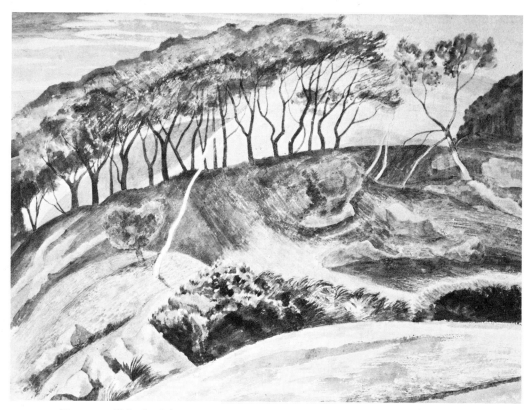

Trees on a Ridge by John Nash. See also colour plate detail facing page 49

Death of Ophelia, will illustrate at once the subjective use of such details in striking contrast to the local land environment in the painting by Edvard Münch of *Three Girls on a Bridge*. In the Münch painting the earth is seen and painted with severe rhythm but the surface area is comparatively simple in expression and undetailed.

In the photograph on page 76 and the diagram 77, curves and verticals are clearly seen to move from lower left to right. The heavy vertical of the tree is so close to the eye as to be almost overlooked altogether.

The transverse movement in the background plantation is therefore in divided areas, but the eye is taken through the row of trees, again without noticing very much the tree in the foreground.

In the movement of life, we are so conditioned to see beyond obstacles, on the highway, from the window of a train, in the streets of our cities, they are scarcely noticed, and we see sometimes only a small part of the landscape.

Incidentally, the zoom concept of a landscape is frequently introduced almost unconsciously into a picture by the observer.

Three Girls on a Bridge by Edvard Münch. Oslo Kommunes, Kunstsamlinger

Naturalism and non-figurative work

The illustration opposite shows an image drawn from a single area of vision, and the same shapes and related shapes reorganised to form a different image. Both images have an identity, but one has arrived as a result of direct vision, and the other by a different intellectual process. This, in general terms, illustrates the difference between 'figurative' and 'non-figurative' concepts in the interpretation of an environment – here, of the land.

The figurative may be:

1 representational, accurately recorded, but with rejection and selection of some items

2 a camera-eye accuracy of naturalist interpretation with skill and little else, or

3 a realism that comments on the character and mood of the place, as experienced by the artist, and not necessarily as directly seen in accurate colour, form or silhouette.

The prospect of a complex system of shapes may confuse and restrict the inexperienced artist. There is, of course, no substitute for experience, but considerable achievement may be made very quickly using the following approach in the early stages of the work.

A figurative extreme is the completely naturalistic view of the place with carefully drawn detail, and the other, the use of lines, shapes or tones, written notes which describe for the artist the atmosphere and personality of a part or whole of the selected area.

Drawings made by the first method will be useful to the artist in making other images in paint, print, other drawings, collages, etc for further use. Much detail will be needed for further development on these lines, including written notes, especially if access to the place is unlikely. Gaps in information discovered later will prove very disappointing.

The non-figurative extreme will produce a translated vision, and an entirely new and previously unconsidered identity may result, which at first impression may not resemble the original image at all. In the working drawings on pages 72 and 73, there is clearly an intention to retain and enlarge upon many of the shapes, tones, harmonies and colours of the place seen. Personal shorthand notes referring to colours or identity of items are made in these drawings, every detail, in fact,

which may be needed for a later reassembling of the constituent parts of the image. These notes could not be made by a camera, because no photograph can supply the mood and state of mind, or the personal comfort or discomfort of the artist whilst making the record.

Reference to a photograph is a help to some artists, whereas to others it would prove a hindrance. One possible advantage is the degree of disorganisation which occurs through the lens and in exposure and developing. There are unexpected and often most exciting new concepts made through what might be described as the 'lying' nature of photography, especially if the drawing is of a non-figurative nature.

Obviously the camera will also be useful to the artist who needs to make a strictly accurate representational drawing of his subject. This type of drawing can be assisted by details of fact and form which a photograph will give. The photograph of a ploughed field (page 68) illustrates very clearly the ease with which a

seen landscape can suggest a completely non-figurative treatment of the subject. Note particularly the left and right hard lines which could be in several contrasted colours, and the abrupt interruption of the dark shape (hedge) and the light shape (field) meeting left of centre. Presume for a moment that the upper area is clear orange, the hedge dark blue and the field scarlet, and at once a pattern colour design has occurred. On pages 70 and 71 accuracy might usefully be added to location drawings by means of camera detail, but as a general rule, the strong earthy quality of uncultivated land can be recorded by the eye, by written notes and maximum effort by the artist.

The photograph of a cornfield on page 68 may be considered to represent a figurative image of a location. That on page 91 shows the same image deliberately cut and reassembled to form a simple and obvious example of a method of reorganising such a picture into a non-figurative form. The original shapes and tones are here used without any respect to visual naturalism. It is reasonable to suppose that some elements of the mood and ambience of the location may be commented upon in the reassembled picture. It should be understood that such reorganisation is not made with a particular aim to achieve this 'reminder' of the original, and stands in its own right and merits as a design for which the landscape was a form of catalyst or merely a starting point.

Suppliers

Great Britain

Artists' materials

Crafts Unlimited (Reeves-Dryad)
178 Kensington High
Street, London W8

11–12 Precinct Centre
Oxford Road
Manchester 13

202 Bath Street
Glasgow C2

Dryad Limited
Northgates
Leicester LE1 4QR

L Cornelissen and Sons
22 Great Queen Street
London WC2

Lechertier Barbe Limited
95 Jermyn Street
London SW1

Clifford Milburn Limited
54 Fleet Street
London EC4

Reeves and Sons Limited
Lincoln Road
Enfield
Middlesex

Robersons and Company Limited
71 Parkway
London NW1

George Rowney and Company Limited
10 Percy Street
London W1

Winsor and Newton Limited
51 Rathbone Place
London W1

United States

Artists' materials

Arthur Brown and Bro Inc
2 West 46 Street
New York, NY 10036

A I Friedman Inc
25 West 45 Street
New York, NY 10036

Grumbacher
460 West 34 Street
New York

The Morilla Company Inc
43 21st Street,
Long Island City
New York and
2866 West 7 Street
Los Angeles, California

*New Masters Art Division
California Products
Corporation*
169 Waverley Street
Cambridge‘ Massachusetts

Stafford-Reeves Inc
626 Greenwich Street
New York, NY 10014

Steig Products
PO Box 19, Lakewood
New Jersey 08701

Winsor and Newton Inc
555 Winsor Drive
Secaucus, New Jersey
07094

Index